IMAGES
of America

CLIFTON
THE BOOMTOWN YEARS

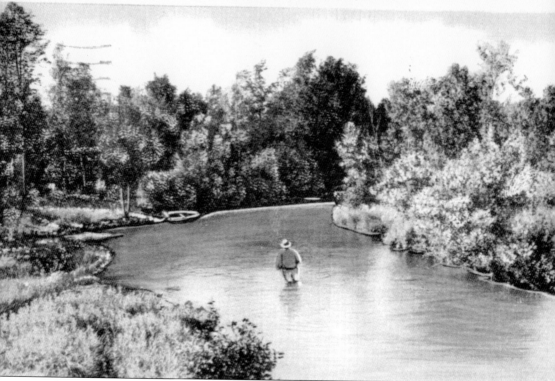

"Greetings from Clifton, N. J.," read the old standby headline for such common postcards of the day. Yet the idyllic setting of this river scene masked what Clifton would become after its 1917 birth from the old Acquackanonk Township. A boom-bust-boom cycle punctuated the decades until the 1950s, when Clifton became New Jersey's fastest-growing city. (Courtesy of the Mark S. Auerbach collection.)

On the cover: Please see page 78. (Courtesy of the Paterson Museum/Paterson News Collection.)

IMAGES
of America

CLIFTON
THE BOOMTOWN YEARS

Philip M. Read

ARCADIA
PUBLISHING

Published by Arcadia Publishing
Charleston SC, Chicago IL, Portsmouth NH, San Francisco CA

Printed in the United States of America

Library of Congress Catalog Card Number: 2006934443

For all general information contact Arcadia Publishing at:
Telephone 843-853-2070
Fax 843-853-0044
E-mail sales@arcadiapublishing.com
For customer service and orders:
Toll-Free 1-888-313-2665

Visit us on the Internet at www.arcadiapublishing.com

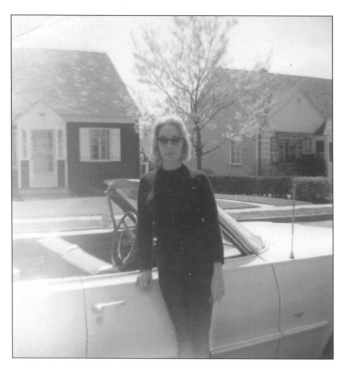

In Clifton's Allwood section, Glory Read stands beside the young family's first new automobile, a 1963 Chevy Impala convertible, with striking red interior. The Reads in the early 1960s lived in the family Cape Cod at 119 Harrington Road, at the corner of Woods End Road.

CONTENTS

ACKNOWLEDGMENTS

There are certain people whose contributions made this pictorial work possible. As such, words of thanks go to Jack De Stefano, director of the Paterson Museum, for access to the museum's photograph archives from the *Paterson News*; Mark S. Auerbach, historian, for access to his sizable collection of Clifton images; Dale Bedford, research librarian of the Clifton Public Library; the staff of the local history room at Paterson's historic Danforth Library; Neil Dudiak, son of Stephen Dudiak, for access to the famed New Jersey builder's scrapbooks; and librarian Brad Small of the Charles F. Cummings New Jersey Information Center at the Newark Public Library.

This work—*Clifton: The Boomtown Years*—is dedicated to my hometown, Clifton, on the occasion of its 90th anniversary in 2007, and to my family, Nancy, Lauren, and Philip Jr., and my mother, Glory Francis Meehan Read, who has called Clifton home for nearly 50 years.

INTRODUCTION

The year was 1952, and New Jersey was gripped by the postwar boom. Newspapers were filled with advertisements for such large-scale housing developments as Montclair Vista, whose split-level designs were the direct result of architects carving up space for a "TV room" in the new era of television.

Elsewhere on Clifton's Hazel Street, 31 homes were sold in one weekend alone at Clifton Village, where two-bedroom ranches with oversize living rooms and picture windows, all priced at $8,990, were being hawked to World War II veterans with no-money-down enticements. "Mr. Vet . . . Here's Your Best Bet! $59 Monthly," read the sales pitch.

In the *Newark News* one Sunday, there was the headline "Clifton: Fastest Growing City" atop these words:

Where prosperous farmers once raised radishes, harried commuters now are rearing children and attempting to meet mortgage payments on their 5 1/2-room castles.

Where frustrated golfers once beat the brush for lost balls, thousands of autos and trucks now sweep along a white ribbon of highway.

Where there was once a garbage dump, there is Nash Park with its 1 1/2 acres of playgrounds, five baseball diamonds, two football fields, a field house and a wading pool.

This is Clifton—New Jersey's fastest growing city.

As diversions, the new arrivals would venture to such places as the bowling alley "Bowlero, At the Crossroads of Routes 46 and S-3" or the cocktail lounge at the Rizzuto-Berra Bowling Lanes, opened by Yankee greats Yogi Berra and Phil "the Scooter" Rizzuto, or even at the Claremont Diner.

A short drive down a new concrete highway would take them to Great Eastern Mills, billed as "America's Greatest Discount Shopping Center." In a few short years, the new arrivals' children would rush down the aisle there for a chance at a tall, thin, and salty 19¢ bag of popcorn and a chance to pick up the latest 45, such as "She Loves You," recorded on the Swan label by the Beatles and costing a week's allowance at 60¢.

Growth was so robust that Mayor Fred G. de Vido had the enviable position of telling Clifton's 70,000 people that their taxes would not be going up.

Yet the boom—driven by industry as well as new arrivals—did not come without its share of red flags.

In Clifton's Allwood section in 1953, homeowners voiced objections to the "alarming trend" of residential acreage—169 acres in all—that had been rezoned for industry. There was also worry

in the Richfield section, where members of the Robin Hood Village Club sought assurances that a park would be created on a "white elegant" parcel once acquired for a school that was never built.

Two years later, an editorial writer hailed one push back to the automobile age. "Clifton has had a narrow escape," the editorial read. "If the applicant for a license to operate a used-car lot on Route 3 had not withdrawn his request, Clifton could have seen the start of an automobile alley along that express highway."

Amid all the back-and-forth, a grand stadium for 12,000 fans was built along one of Clifton's many highways and byways. It would become home to Clifton's "goodwill ambassadors," namely, Clifton High's Mustang Marching Band, the "Showband of the Northeast." As the baby boomers moved into new neighborhoods, Clifton became a bedrock of the middle class. Its vitality would give rise to a burgeoning, top-ranked high school that, by sheer size, could offer more advanced placement courses than far wealthier towns.

By 1967, the year of the golden jubilee marking Clifton's 50th anniversary, William Power, writing for the *Paterson News*, reported that as many as 200,000 turned out for the city's parade-of-parades. It was a festive year. At Yankee Stadium, before 5,000 of his fellow Cliftonites, Mayor Joseph Vanecek threw out the first ball.

Clifton's own Frankie Randall, the teen heartthrob who starred in 1965's *Wild on the Beach*, was to sing "The Star-Spangled Banner" at the pregame ceremonies. But it never happened; he was stuck in traffic.

One

THE GOOD OLD DAYS

H. G. Scheel once practiced the real estate trade at his offices on Clifton's Main Avenue.

He had building lots to sell, priced $150 and up and costing the buyer just $5 a month with 10 percent down. The world was getting smaller in the village of Clifton, which was then a part of the larger Acquackanonk Township. The population was barely 11,000, yet churches were opening, and the nation was in the throes of a great immigration, bursting the industrial centers of neighboring Paterson and Passaic. It was only a matter of time.

"Look over the past year's growth of Clifton and figure what its growth will be two years from now," his company said in a for sale classified advertisement back in 1908. "Get in on the ground floor and put your money where it is safe and make a big profit. Call on us, and we will convince you that it is wise to buy Clifton property."

That same year, Roosevelt Park and its beautiful home sites were being marketed to anyone wanting to stake a claim just a block from Clifton's Erie Railroad station.

The pitch was right on the money. By 1917, the year of Clifton's incorporation as a city in its own right, the population had swelled to 24,000. Just nine short years had elapsed since the advertisement.

It was a boom time by any measure, yet just a taste of what was to come. Clifton, the village of yesteryear, was passing into the history books as the new American century took hold.

On the lawn at School No. 6 in Clifton's Athenia section in June 1920, just three years after Clifton's incorporation, the class motto was Perseverance Wins. And it was needed; rapid change was afoot.

At graduation services there, young May Snyder stood to give a recitation about a fellow classmate no doubt charmed with an industry still in its infancy. The title was "Aunt Viney at the Moving Pictures."

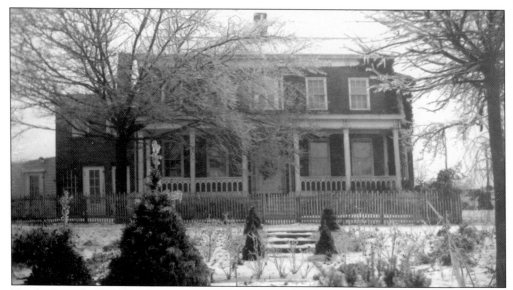

Not far from the WPAT radio towers is the Van Riper house on Broad Street, near the Bloomfield border. "This 1745 stone house was rebuilt by Phillip Van Riper ca. 1793," reads a sign erected there in the 1970s. "This federal styling is rare in this area." Clifton was then a piece of a much larger Acquackanonk Township, a western portion of which is seen in this map. As for Phillip Van Riper, he and some of his descendents are buried in Mount Hebron Cemetery on Valley Road, just along Clifton's border with Montclair. The cemetery is noted as the final resting place of many notables, including Herman Hupfeld, the lyricist who penned "As Time Goes By" (made famous in the movie *Casablanca*), and Shirley Booth, who played the maid in the 1960s hit television series *Hazel*. (Above, courtesy of the Clifton Public Library.)

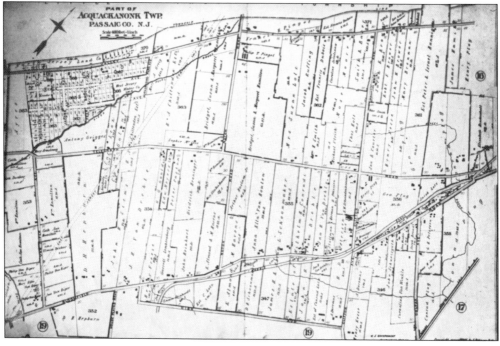

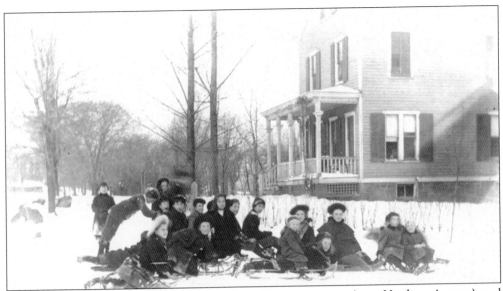

Nearly two dozen children man their sleds at Passaic Avenue (now Harding Avenue) and Second Street around 1882. Not far away, at the southeast corner of Main and Clifton Avenues, the ice-skating pond was another winter diversion for children. In the newspapers in the early 1890s, there was no shortage of tips on parenting. "About Your Boys," read one headline. "Make home a pleasant place; see to it that the boys don't have to go somewhere else to secure proper freedom and congenial companionship," read the advice. "Take time and pains to make them feel comfortable and contented, and they will not want to spend their evenings away from home." Of course, that did not include letting one's parental guard down, the writer suggested: "Pick your son's associates. See to it that he has no friends you know not about." (Courtesy of the Clifton Public Library.)

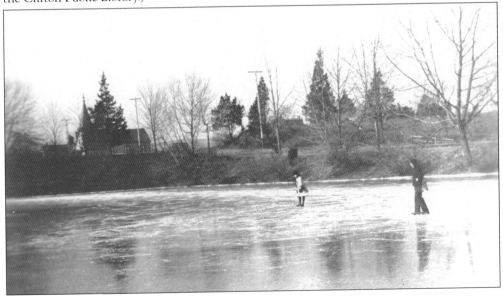

Clifton letter carrier George Duffus of Passaic makes the rounds around 1903. Just two years later, there were plenty of sights to take in across Clifton. For one, a Paterson basket manufacturer was building a shop at Piaget and Main Avenues and announced that he would erect a handsome residence there as well. A "green motorman," meanwhile, took a trolley car scheduled to end its run in Lakeview all the way to Passaic instead. "Passengers aboard the car were surprised that they didn't have to pay another fare," a reporter noted. (Courtesy of the Clifton Public Library.)

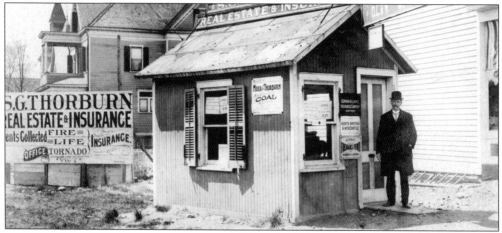

At the center of the village of Clifton, around 1907, stood the insurance offices of S. G. Thorburn at Clifton and Main Avenues. Among the offerings were North British and Mercantile and the Fireman's Fund. The neighborhood was by no means a sleepy one. Just down the road in 1905, pigs broke out of their pen and strolled down Main Avenue, frightening women, children, and several horses, according to the October 14, 1905, edition of the *Passaic City Daily News*. "The stablemen and jockeys that are at the [race]track all turned out to drive the pigs back to their pen, but the pigs were stubborn and would not go back," wrote the author of the "Clifton Notes" section. "It took several hours of throwing stones at them and hitting them with bale sticks before they were returned to their pen, which afforded much amusement to the bystanders." Come 1925, Thorburn was elected Clifton's mayor. (Courtesy of the Clifton Public Library.)

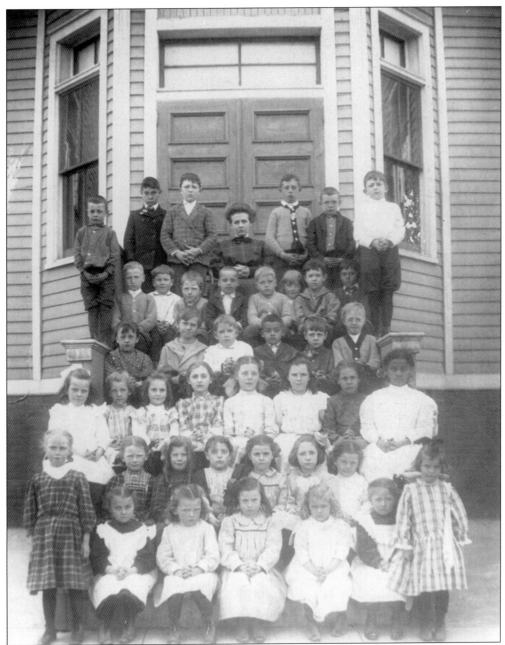

In 1905, a dozen years before the founding of Clifton, schoolchildren pose for a photograph on the steps of old School No. 2 in the Richfield section in what was Acquackanonk Township. Across town that same year, the board of education voted to open a night school in Botany. The reason was the large number of foreign children who worked in the factories. (Courtesy of the Clifton Public Library.)

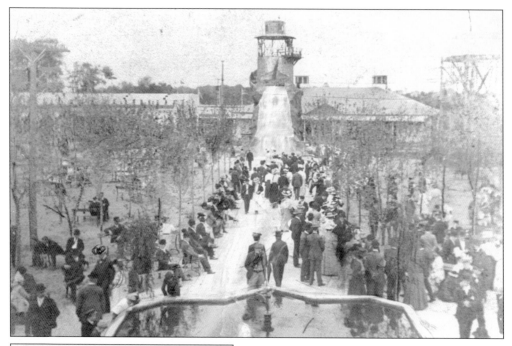

Never trouble trouble before trouble troubles you.-

The prismatic cascades, or waterfalls, were a main attraction at Fairyland, a 10-acre amusement park off Main Avenue, near today's Corrado's Supermarket. An advertising card from the era comes with this advice: "Never trouble trouble before trouble troubles you." The cascades, shown about 1907, were brightened by colored lights projected at them from various vantage points. (Female entertainers stood behind the waters as they sang and danced.) The park would last only a few short years, closing forever in 1909. (Above, courtesy of the Clifton Public Library; left, courtesy of the Mark S. Auerbach collection.)

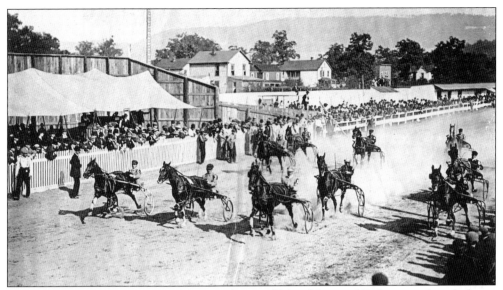

Clifton's racetrack, near today's Clifton Stadium and Main Memorial Park, was a place for horse racing in 1905, seen above, and bicycle contests in 1910. Yet the racetrack had its share of run-ins years earlier. On January 6, 1891, as grand jurors were seated, a Judge Dixon described the track as a "pest house" that had been "corrupting the morals of the county." There had been an indictment before, something not lost on the judge. "The law is amply sufficient to deal with the evil," a newspaper writer said of the judge's stance, "if those who are charged with its enforcement only do their duty." The bookmakers were indicted. By January 21, the track was described as a "dull" place. "There isn't the remotest semblance of gambling, and the 2,500 people who came prepared to bet wore their sourest looks," wrote the *Passaic City Daily News*. (Above, courtesy of the Paterson Museum/Paterson News Collection; below, courtesy of the Clifton Public Library.)

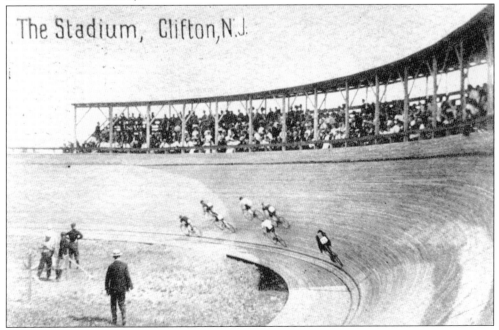

The Stadium, Clifton, N.J.

All the betting associated with the Clifton Racetrack meant a booming business to not only the bookies but the bars as well. At the Clifton Racetrack Hotel, owner William Lemke once played host to James "Diamond Jim" Brady, who started out as a bellboy and became a millionaire known for his flashy dress and his hearty appetite. By November 8, 1924, decades after betting stopped and seven years after Diamond Jim's death, the old hotel stood abandoned. "In this dismantled barroom, sports of another day washed dust from their whistles," wrote a Newark newspaper photographer. (Courtesy of the Newark Public Library.)

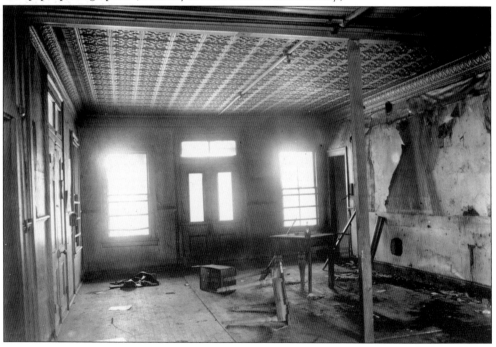

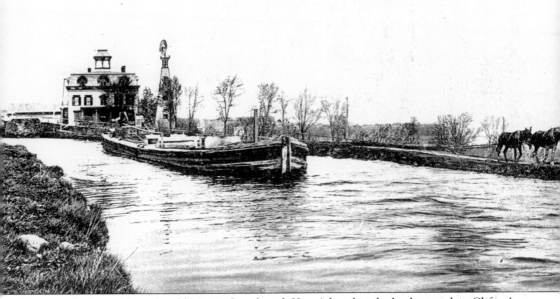

Horses pull a barge along the old Morris Canal, with Kesse's hotel in the background, in Clifton's Richfield around 1908. The western stretch of Clifton was largely farmland, but in downtown, the new century came with its own growth spurt. "Roosevelt Park, Clifton. One block from the Erie Station and its beautiful home sites," read an advertisement in April of that year. In a "Clifton Notes" section of the daily newspaper, the writer notes that ground was broken for a new home at DeMott Avenue and Second Street and then decides to take in the sights. "Clifton cannot boast of a skating rink," the writer said, "but if someone wants to walk over to the Clifton High School [then at Clifton Avenue and First Street] . . . one can see a crowd of Clifton's young folk that would fill a good-sized hall, whirling over the broad concrete walks on roller skates." (Courtesy of the Mark S. Auerbach collection.)

Back in 1913, Clifton Hand Laundry at 11 Second Street knew how to entice the buying public, offering this comforting portrait of what life would be like if only people handed over their laundry chores—for a fee—to someone else. "Oh the snore, the beautiful snore," reads the poem on the back of this postcard. "Filling the chamber from ceiling to floor. Over the coverlet, under the sheet, from her wee dimpled chin to her pretty feet. . . . And why did she sleep so soundly and snore so musically, but because her blankets were soft and clean and laundered by us! Do likewise and phone us." The proprietor is listed as J. Kroener. (Courtesy of the Mark S. Auerbach collection.)

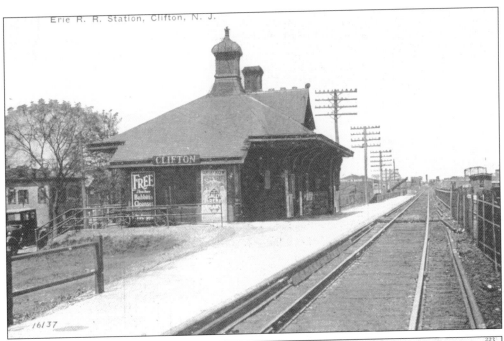

16137

Advertising was nothing new in the 1920s, as evidenced at the Clifton train station of the Erie Railroad. Billboards enticed commuters to buy Babbitt products, including BAB-O, the bathroom brightener. Back in 1928, Babbitt was hawking the product: "When Tommy smudges the tub—BAB-O brightens with child-like ease." No more "stubborn bathtub line," it promised. The Clifton station also sports a poster for *Sally, Irene and Mary*. The 1925 silent movie, based on the musical comedy by Edward Dowling, was actress Joan Crawford's breakthrough film. She played the dreamy Irene, whose Charleston dance number in the film was one of the defining moments of the 1920s. (Above, courtesy of the Mark S. Auerbach collection.)

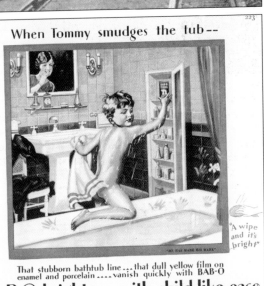

19

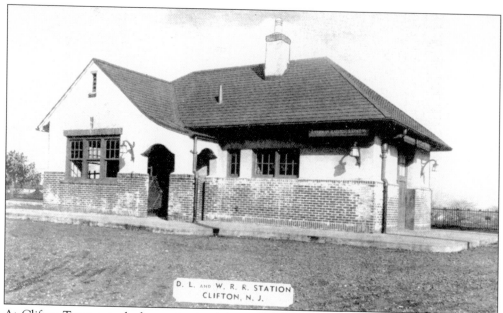

D. L. AND W. R. R. STATION
CLIFTON, N. J.

At Clifton Terrace, tucked away in the Athenia section, is the Clifton station, part of the old Delaware, Lackawanna and Western Railroad. John Hughes, the developer of Athenia, built and then donated the original station to the Lackawanna Railroad, according to historian David Van Dillen in *A Clifton Sampler*. Today the station offers 30-minute rides weekdays and weekends to Hoboken on New Jersey Transit's Main Line. Riders can catch trains to Ridgewood, as well as Waldwick and Suffern. (Courtesy of the Mark S. Auerbach collection.)

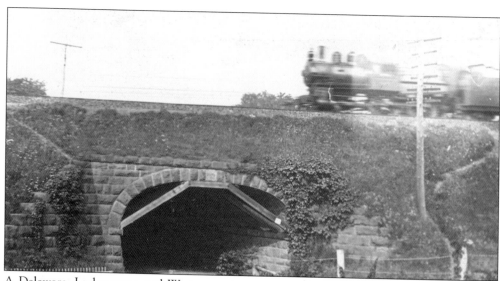

A Delaware, Lackawanna and Western train races over the viaduct at Clifton Avenue, near Paulison Avenue, around 1905. Some 15 years later, in 1920, the viaduct was replaced. That year, transportation was a topic down on Main Avenue as well. Businessmen went before a grand jury to force public service to lay oil or water along its trolley tracks, which were creating a "dust nuisance" on the main thoroughfare. (Courtesy of the Clifton Public Library.)

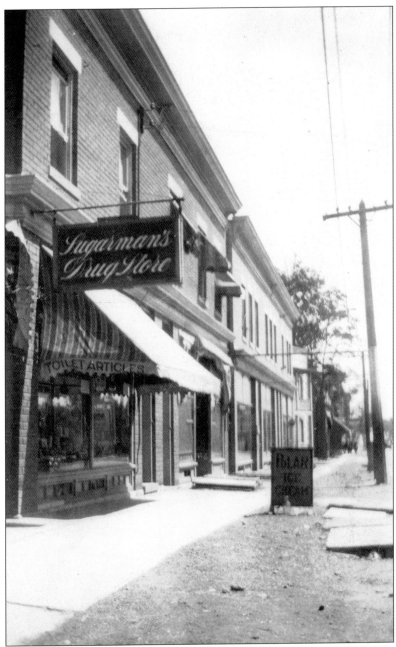

Sugarman's Drug Store, which stood at the southeast corner of Main and Madison Avenues around 1920, was also a place to pick up some Polar brand ice cream. Later the shop became Bellinson's Rexall. Nearby businesses included the shop of J. M. Peter, who touted his establishment as the Clifton Delicatessen at 703 Main Avenue. "Lunches that please all in your party is your aim," read its advertisement in May 1920. The advertisement featured a sketch of a can of Domino Golden Syrup. At Clifton and Main Avenues, the shop of W. S. Pontier hawked "outing footwear," including the "well-known KEDS." Its advertising pitch was "Some have leather, white enameled soles and heels, while others have all rubber, with uppers of fine quality heavy canvass." (Courtesy of the Clifton Public Library.)

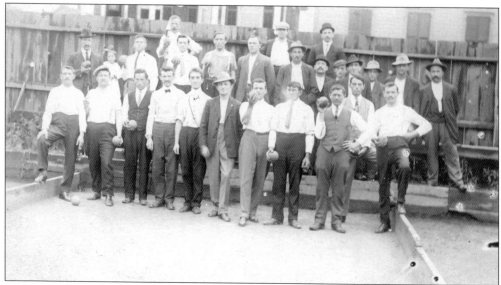

Clifton's Botany neighborhood was an Italian enclave, so the game of bocce was well loved. Bocce derives from the Latin word *bottia*, meaning boss. The game, lauded in some sectors for its contribution to athleticism and competition, was not always praised. In 1576, the Republic of Venice condemned the sport, invoking fines and imprisonment for its players. The Roman Catholic Church also deemed it a form of gambling and forbid clergymen to partake of the entertainment. Fast-forward to 1947, and the Bocce World Championships were born. Elsewhere in Botany, on Dayton Street, folks gather at the grocery store. (Courtesy of the Clifton Public Library.)

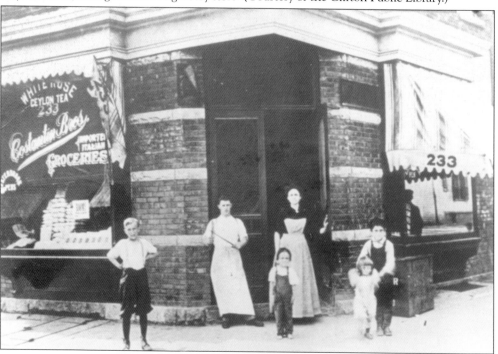

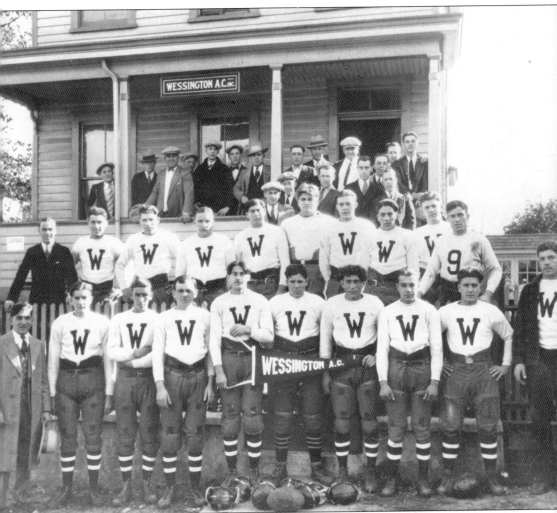

"The Wonderful Wessingtons" of the Wessington Athletic Club line up in the late 1920s. Behind them is John A. Celentano, later a judge, shown wearing a striped tie in the upper right. Vic Constantine is smiling out from under a cap near the center veranda. Emil Bondinell, captain of the 1924 Clifton High School baseball team, is at left of the second row of players; standout Art Argauer is front and center. In 1970, this was one of the historic photographs on display at the First National Bank on Parker Avenue in Clifton's Botany village. (Courtesy of the Clifton Public Library.)

In 1924, long after the old Clifton Racetrack's day had come and gone, the acreage was ripe for what would follow: parks, a new high school, playing fields, and, eventually, a stadium. In the 1920s, Clifton's population would surge from 26,470 to 46,875 by decade's end, then barely climb again until the post–World War II boom. (Courtesy of the Newark Public Library.)

Clifton village was even rural at its core in this view looking east along Passaic Avenue (now Harding Avenue). In the foreground is today's Fifth Street. The street is believed to have taken its newer name from the 29th president, Warren G. Harding, who died during his presidency while on a trip to California in 1923. (Courtesy of the Clifton Public Library.)

The Elks fraternal organization was formally organized on February 16, 1868, in New York City under the full corporate name of Benevolent and Protective Order of Elks of the United States of America. Its four cardinal virtues are charity, justice, brotherly love, and fidelity. In Clifton, chapter 1569, shown in this updated photograph, makes its home at 725 Van Houten Avenue. The organization had its roots in a group called the Jolly Corks, who raised their glasses to a toast that begins, "Now is the hour when Elkdom's tower / is darkened by the shroud of night, / And father time on his silver chime / Tolls off each moment's flight. / In Cloistered halls each Elk recalls / His Brothers where'er they be, / And traces their faces to well-known places / In the annals of memory." (Courtesy of the Paterson Museum/Paterson News Collection.)

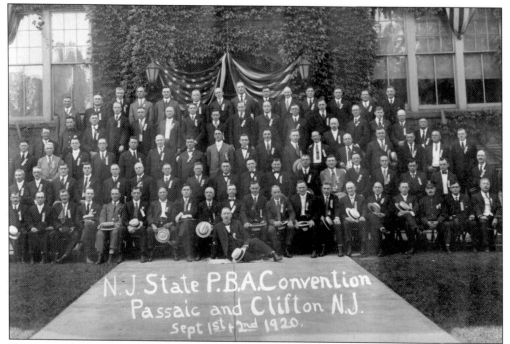

Hundreds of American flags were massed from Clifton's city hall on Main Avenue all the way to Passaic in September 1920, readying for a parade of 3,000, as about 52 police departments from across New Jersey first gathered at Clifton's Masonic lodge to kick off their 20th convention. The front page of the *Passaic Daily News* carried a picture of Clifton police chief William J. Coughlan, with news that Clifton mayor George R. Connors presented the keys to the city to the 150 delegates. There was some lighthearted ribbing. Mayor Connors was introduced as coming from "the terrible town of Clifton." But Connors, taking exception to a remark that Passaic had the best police department, insisted Clifton's was number one. Regardless, the police officers from both towns posed together for this photograph—while in Passaic. (Courtesy of the Mark S. Auerbach collection.)

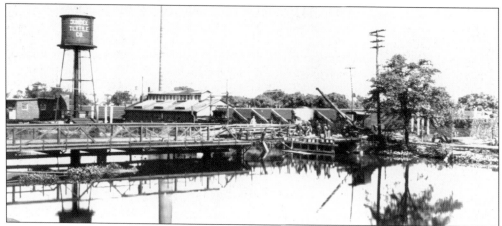

The Dundee dam and canal were created in 1861, allowing mills such as the Dundee Textile Company to draw water and power their operations. In 1935, this was the view looking northeast to the bridge across the Dundee canal at Clifton's Ackerman Avenue. To the right is Clifton Paper Board. (Courtesy of the Paterson Museum/Paterson News Collection.)

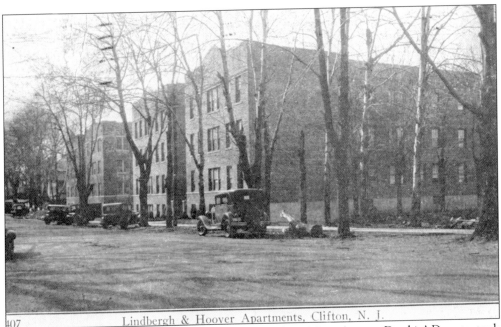

Lindbergh & Hoover Apartments, Clifton, N. J.

The Lindbergh and Hoover Apartments, behind today's Main Avenue Dunkin' Donuts, took their name from two standouts of the 1920s, Charles Lindbergh, the first person to fly solo across the Atlantic Ocean (1927) and Pres. Herbert Hoover, who served until the Roaring Twenties imploded into the Great Depression. "General prosperity had been a great ally in my election in 1928," President Hoover would later write. "General depression, who superceded, was in some part responsible for my defeat in 1932." (Courtesy of the Mark S. Auerbach collection.)

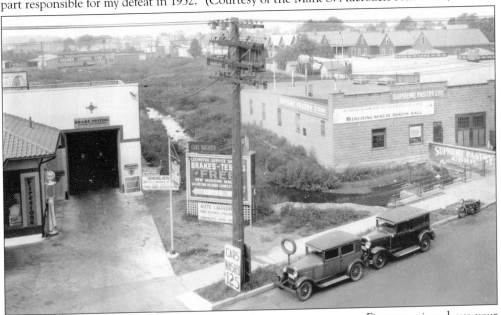

On Clifton's Lexington Avenue, there was a place to get some new Firestone tires, have your brakes adjusted, and even get your old Ford washed for $1.25. Next store, bakers were at work at Supreme Pastry. In the far left background is the Kramer Lumber Company. (Courtesy of the Paterson Museum/Paterson News Collection.)

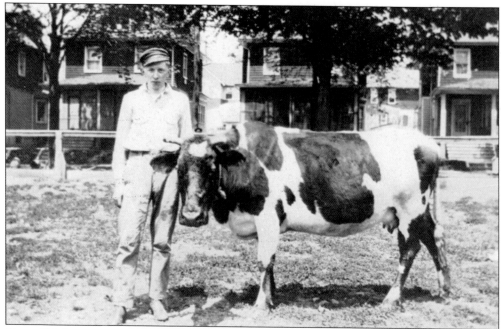

Got milk? A young man at Van Der Hey Farm stands with a cow at 79 Hadley Avenue, in an updated picture; by September 1934, heads turned for the horse-drawn milk wagon of Sisco Dairy Company in a photograph attributed to Albin Heinrichs. In neighboring Passaic that month, the child star of radio Baby Rose Marie was a headliner at the Capital Theater in an event that also featured Bob Hall, a vaudeville favorite. In the *Herald-News*, one headline proclaimed, "Clifton Girls Win First Prize in Joan Crawford 'Eyes' Contest." The winners received tickets to the Joan Crawford and Clark Gable film *Chained* showing at Passaic's Montauk Theater. The first-place winner, Mary Heldt of Clifton's Highland Avenue, won passes for two for a month. (Above, courtesy of the Paterson Museum/Paterson News Collection; below, courtesy of the Clifton Public Library.)

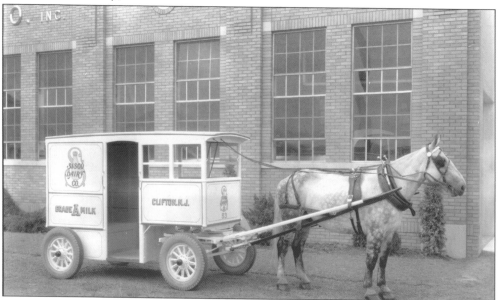

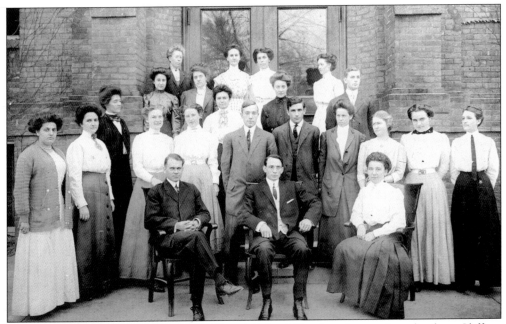

The teaching staff of old School No. 10 and School No. 3 gather at the school, at Cliffton Avenue near Main Avenue, for this portrait early in the last century. The staff's names, penciled in on the back of the photograph, are identified as, Martha Royer, Katherine Ferriter, Miss Nye, Sarah Dietz, Vera La Mella, Helen Bustard, Lottie Slater, Dottie Robinson, Max Livingston, Mildred Ayres, Teresa Grish, Josephine Hock, Bessie Corkey, "Bucky" Vail, George J. Smith, Lillian Kane, Margaret Wallace, Eleanor Sharpe, Julie Hoffmeister, Edward Leary, and Harry Collister. (Courtesy of the Mark S. Auerbach collection.)

In June 1909, Clifton High School operated out of School No. 10, at Clifton Avenue and First Street. Class day exercises included a short sketch titled "The Last Voyage of the Naughty-Nine." Starring in this sketch were, from left to right, Mabel A. Libby as the captain, Agnes B. Weller as the first mate, Bessie G. Velders as the man at the log, Nellie M. Brown as the wireless operator, and Grace C. Burroughs as the lookout. The show was accompanied by the school orchestra and the girls' glee club. Among the tunes sung that evening of June 22 were "Mermaids Evening Song" and "Song of the Sea." (Courtesy of the Clifton Public Library.)

Clifton's High School's yearbook, the *Reflector*, was also a reflection of commerce in 1921, just four years after the city's 1917 founding. At S. King Confectionery and Ice Cream on Main Avenue, the brand that drew them in was Horton's Ice Cream. It had staying power. More than a quarter-century later, in 1947, Horton unveiled a new mixture. "Six new chocolate flavors blended into one!" the company boasted. "Tastes richer because it's made with costlier chocolate."

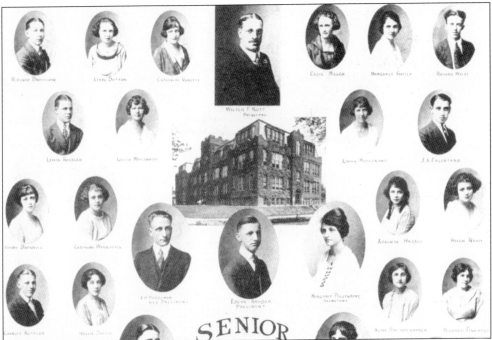

Clifton High School's class of 1921 attended the old ivy-covered high school, now a municipal parking lot at Clifton Avenue and First Street. In the *Reflector*, the yearbook, the 25 graduates pictured around their school and principal, Walter Nutt, were not ones for smiling at the camera, but they had a sense of humor, as noted in the yearbook cartoon "It Takes All Kinds to Make Up a High School."

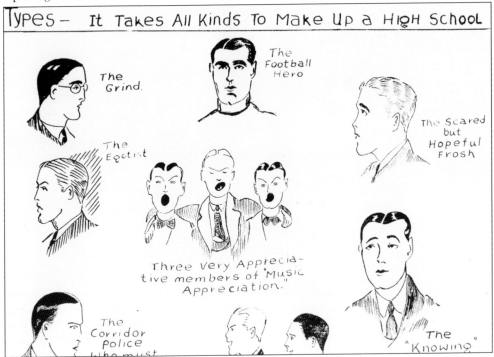

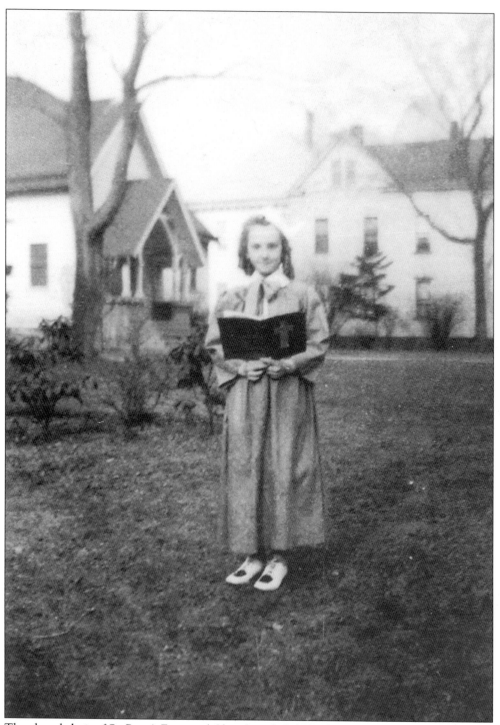

The chapel choir of St. Peter's Episcopal Church included Elizabeth Ann Plokhooy, shown here at eight years of age in front of the parish hall, around 1942. "There were little choir pews in the chapel at the time," said Alice Dymek, her sister and a longtime parishioner. "They had choir mothers." (Courtesy of the Dymek family.)

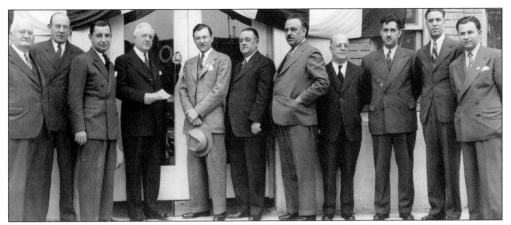

Days before the municipal election, Clifton's officialdom gathered for the unveiling of the new addition to city hall on Main Avenue. Among the dignitaries were Mayor Godfrey M. Meyer and councilmen Edward Earnshaw, John Hamil, and Louis Bertoni. The dedication was seen as the climax to the silver jubilee celebration. The year would prove to be a good one for incumbents. The entire council was reelected on May 12, 1942. For one, Earnshaw's résumé included work as an agricultural chemist, and he was a onetime owner of the Bon Arbor Chemical Company in Paterson. (Courtesy of the Paterson Museum/Paterson News Collection.)

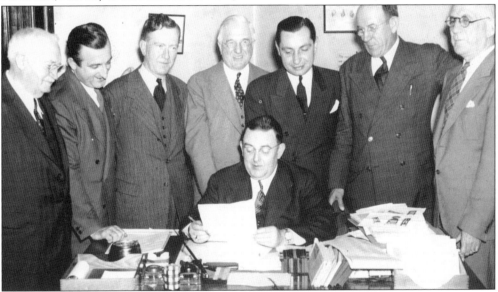

In May 1942, Clifton's councilmen were all reelected, with Mayor Godfrey M. Meyer the top vote-getter. That was expected to propel the New York banker into the mayor's seat yet again. But come the May 26 reorganization, fourth-place finisher William E. Dewey was sworn in by city manager William A. Miller, seated. But not without an outburst in Miller's office before the vote, taken in the face of a 1,100-signature petition demanding Meyer should return to the mayor's job. At day's end, Dewey, also a freeholder, gave what he described as probably "the longest speech" he ever made. "None of us, I am sure, have any false impressions about the permanency of public office," Dewey said. "Today we are here. Tomorrow we are gone." Back at the dais that year are, from left to right, (standing) Edward Earnshaw, Michael Shershin, Dewey, Meyer, Louis Bertoni, John Hamil, and Edward Birmingham. (Courtesy of the Paterson Museum/Paterson News Collection.)

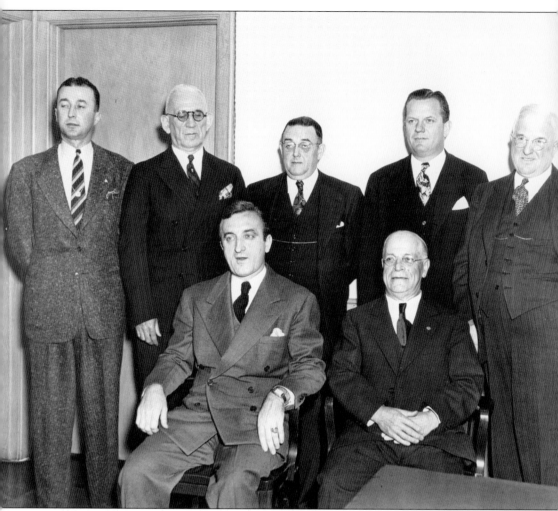

The year was 1946, and Walter Nutt, seated right, would become Clifton's mayor. At this seating of Clifton's councilmen standing are, from left to right, Fred de Vido, Edward Birmingham, city manager William Miller, John W. Surgent, and Godfrey M. Meyer. Seated next to Nutt, the onetime high school principal, is Michael Shershin. Nutt, as the high vote-getter, was chosen to be mayor in the reorganization meeting to follow. "It has always been my feeling that high man should have that honor," Meyer said. "It is the will of the people." (Courtesy of the Paterson Museum/Paterson News Collection.)

Two

SUBURBIA BORN

"Allwood, A New City of Homes in the Making," read the headline in the March 1931 issue of *American Builder and Building Age*. In all, 4,500 homes—mostly of Tudor style in stucco and brick—were to rise on streets with such names as Marlboro Road, home to what was expected to be the first of 18,000 new arrivals to the new Clifton neighborhood.

The model home was furnished by the venerable New Jersey retailer Hahne and Company. There were built-in ironing boards in the kitchens and Cambridge-Wheatley colored tile in the baths. Marketers touted "the New Park City" and "Home and Recreation. All in One, in Allwood."

The economic repercussions of Wall Street's 1929 stock market crash, known as Black Friday, had not yet set in.

Charles H. Reis was standing his ground. "The year 1930 was a poor one for business in general and exceptionally so for building developers," a magazine writer said in the article on Reis's Allwood neighborhood. "It is unusual in such times to find men willing to go ahead with a gigantic house-building program, especially so when the houses produced are to be sold at a moderate price to those with moderate incomes."

One advertisement touted a six-room, two-bath home for a price tag as low as $6,950, with $350 cash down, $400 on delivery of deed, and just $67 a month for payments. A week before the model was opened, newspaper pitches brought out a crowd of 5,000 for a sneak preview on a Sunday afternoon. By December, 100 homes had been sold.

Meanwhile, life went on in a still bustling Clifton.

In May 1930, New Jersey's comptroller John McCutcheon told a gathering that Clifton was rapidly becoming a power in politics. "Rapid growth of population seen as indicator of strides being made here," read an account in the *Passaic Daily News*, then costing just 3¢. A debating team at Clifton High School took on a tough question, "Resolved: That the chain store system is a social and an economic benefit to the American people," winning over the judges in the process. On Harding Avenue, Henry Gould set out on a cross-country trip with his family, taking the wheel of his 1925 model Buick with 73,000 miles on the odometer. Behind him was a homemade "house on wheels," with a sink and running water, a refrigerator, and berths to sleep in.

Over by Godfrey's Pond near Lexington Avenue and East Eighth Street, petition-waving homeowners were in an uproar over a proposal to erect 100 wood bathhouses there. "Scores of persons who have invested their life savings in homes in that vicinity," the newspaper reported, "have joined in a storm of protest against making Godfrey's Pond a public swimming pool."

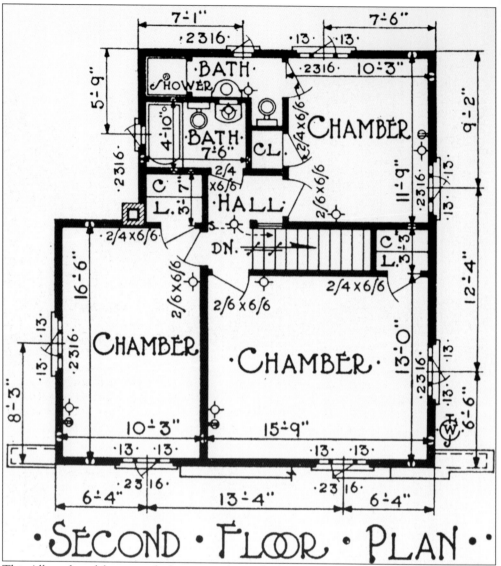

· SECOND · FLOOR · PLAN · ·

This Allwood model came with three second-story bedrooms, all connected via a center hallway.

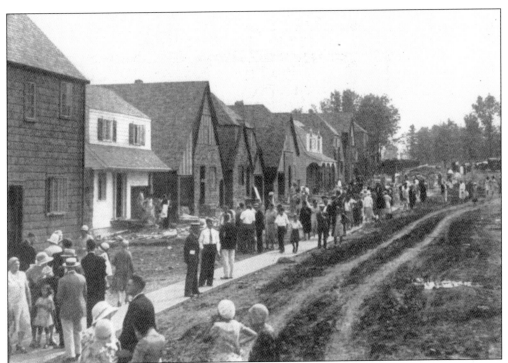

Billboards beckoned new arrivals to Clifton's Allwood, where crowds formed on Marlboro Road even before the model home openings and before the concrete roads had been laid. The development was created on the 300 acres of the old Brighton Mills, which had moved its plant to Georgia. An extra 200 acres of rolling countryside, orchards, and woods was then acquired, according to *American Builder and Building Age* magazine.

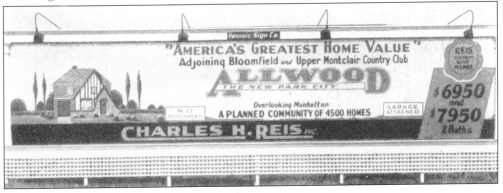

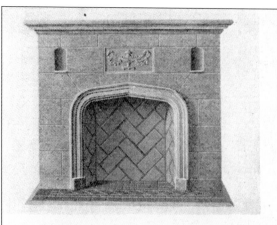
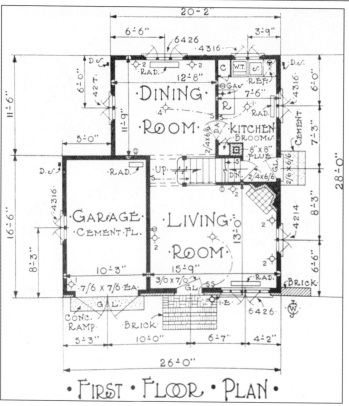

· FIRST · FLOOR · PLAN ·

The living rooms of the Allwood section homes first marketed in 1930 were graced with Readybuilt fireplaces, just one of the many American-made products incorporated into the houses. The baths came with Standard's Pembroke tubs and Fairfax fixtures. The radiator valves were made by Ohio Brass, the hot and cold copper tubing was forged by American Tube Company, and the steam-heating fittings were created by the Essex Foundry Company. All was supported with 2-by-10-inch floor beams, made of fir. At the home's base were concrete floors and fittings. "No ash used," read the specifications.

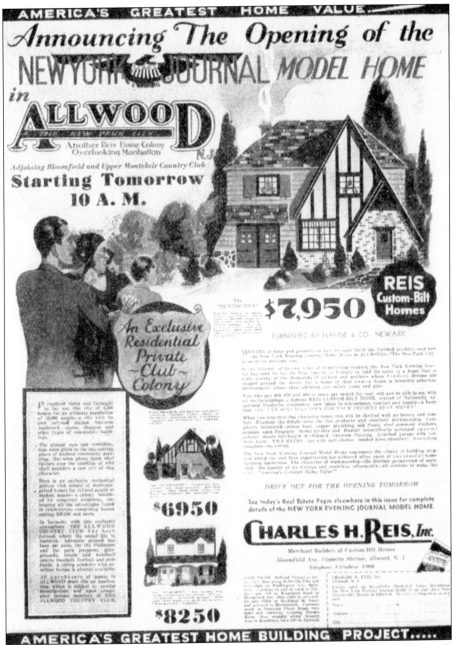

This full-page advertisement appeared in the *New York Journal*, part of a well-thought-out marketing strategy. Similar ones ran in the *Passaic Daily News*. "An exclusive community for select families. Only the most desirable families can purchase homes in Allwood, assuring you congenial neighbors and refined environment," read the advertisement. The developer, Charles Reis, was no novice. He was behind Woodridge's Sunshine City, a neighborhood of 1,000 homes in New Jersey's Bergen County. "In the long run, it takes personal salesmanship to put over actual sales," said Newland Prior, the company's vice president, "but advertising is first needed to create in a prospect's mind some degree of acceptance and confidence even before he sees the house."

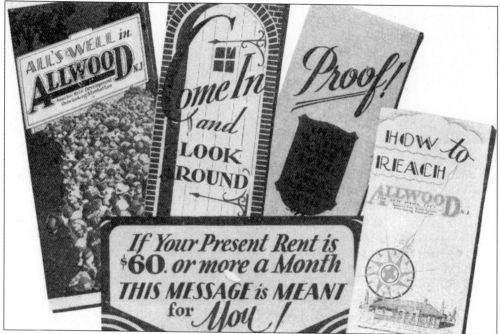

These direct-mail flyers were a how-to on how to buy into the new Allwood community, which was originally to comprise 4,500 homes built over eight years. "Our past experience has taught us that to sell houses, it is as important to advertise as it is to have houses to sell," said Newland Prior, who, as vice president of Charles H. Reis Inc., was also in charge of advertising. With the Depression soon to set in, however, the prospects for creating a seven-acre recreation mecca alongside the development never materialized. Planners had originally envisioned a football field encircled by a running track, as well as a grandstand along the north side of Allwood Road, just south of Market Street. Still there were plenty of diversions in 1930, including the Allwood Tom Thumb Golf Club, one of many then in Clifton. "Here's paradise indeed for the miniature golfer," read an advertisement. "Pleasant, scenic surroundings."

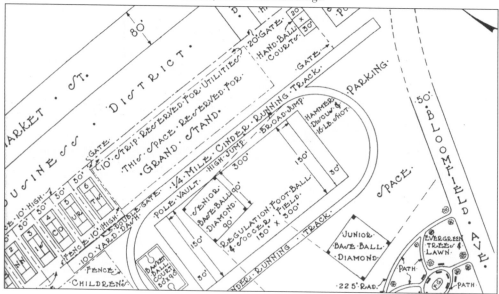

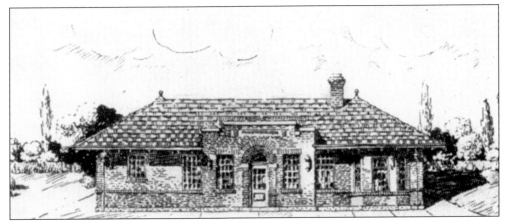

Since the Allwood development was "overlooking Manhattan," the train depot was only fitting. This sketch of the new Allwood railroad station, set back from Bloomfield Avenue and Brighton Road and softened by groupings of lawn and scrubs, appeared in the magazine *American Builder and Building Age*. It was to include a 12-foot-wide platform for commuters taking the Newark branch of the Erie Railroad.

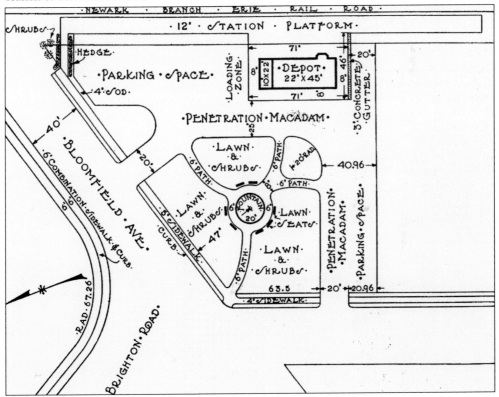

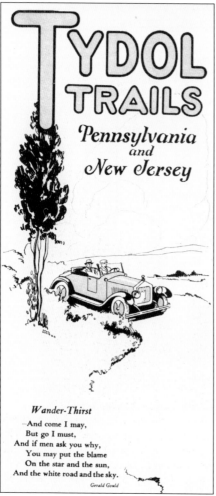

TYDOL TRAILS

Pennsylvania and New Jersey

Wander-Thirst

—And come I may,
But go I must,
And if men ask you why,
You may put the blame
On the star and the sun,
And the white road and the sky.

Gerald Gould

A round Tydol sign, with a red circle at its border, beckons motorists to stop in for some gasoline at this intersection as the sign of St. Clare's Roman Catholic Church, right, directs people to make a right onto Allwood Road to catch a service. In its earlier years in the 1920s, the product was pitched as gasoline with "Get-up and Getaway in every drop." In 1926, motorists stopping at Tydol could pick up a "Tydol Trails" map of New Jersey, whose advertising copy advised them to look for "a beacon to guide you to a new supply of vigor, power and snap" that only Tydol could provide. (Above, courtesy of the Paterson Museum/Paterson News Collection.)

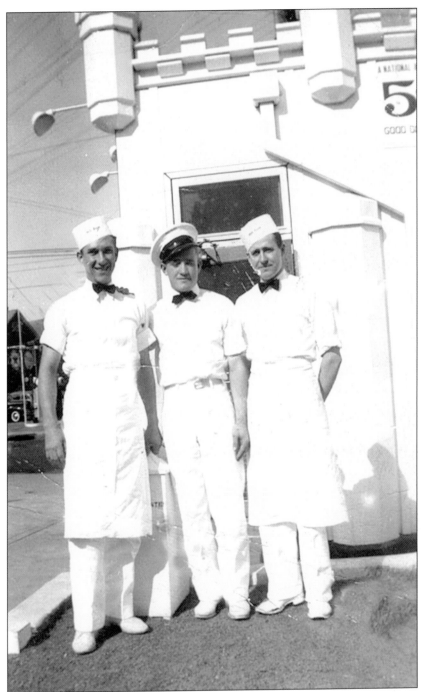

The White Castle in Clifton's downtown has been a landmark for decades. Here three properly dressed employees—all said to be from Tennessee—pose for a photograph in the late 1930s. The shutterbug was Claire Van DerVliet, who once lived across the street. In the 1950s, waitresses would come to a driver's window and hook up a tray to take the order. Patrons could also go inside and sit at the barstool-lined counters. By century's end, however, the original building was removed, and a modern one was there in its stead. (Courtesy of Claire Van DerVliet Pruiksma.)

By 1939, old Tydol's fleet of stations, like this one in eastern Clifton, became Tydol Flying A, with the telltale wings, and by 1956, they became simply Flying A. As an enticement to get some return business, attendants at Tydol Flying A handed out trading cards such as this one, depicting the Airacobra, a single-engine fighter with one shell cannon and four machine guns. "Performance details are a military secret," reads the card, "but the plane is reported to do well over 400 mph." Come the mid-1960s, the name was passing into corporate history, and the stations took the name of Getty Oil. Not before, however, the brand became the sponsor of New York Yankees broadcasts, with a dog named Alexrod and the what-can-possibly-go-wrong slogan "Ooooh, do we worry!"

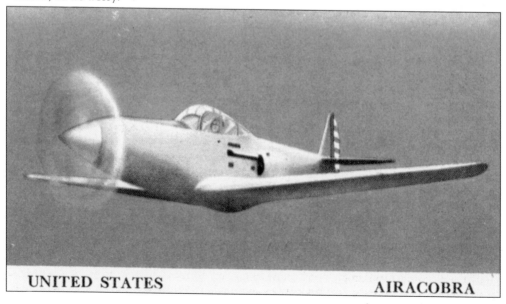

UNITED STATES **AIRACOBRA**

The Richfield section is blanketed in snow in 1930 in this view looking down Erma Avenue toward Van Houten Avenue, near today's Clifton High School. That year, readers of the *Daily News of Passaic* would flip through advertisements hawking the 1930 Nash 400 with its "built-in radiator shutters," sold at Nash-Clifton Company on 752 Main Avenue. For those with a liking of radio and 78 records, there was the new 1930 all-electric Brunswick "Radio-With-Panatrope" for only $185. But readers needed to catch the small print. "Less tubes," it read. One also had to trade in an old radio or phonograph. (Courtesy of the Paterson Museum/Paterson News Collection.)

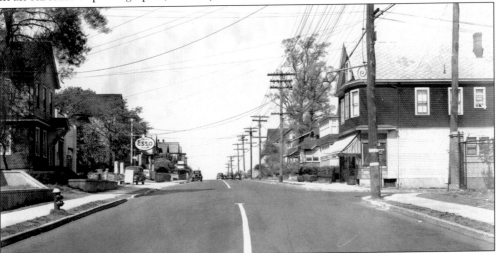

Motorists on Clifton Avenue, traveling past Paulison Avenue on their way downtown, could not make a left at this intersection in May 1937, the date of this photograph. This is because Paulison Avenue did not extend through on a path toward Route 46, which had not yet been built. Still one could stop at an Esso gas station, the predecessor of today's Exxon. The tiger of Esso-advertising fame made its debut in England in the mid-1930s. It was not until tiger advertisements waned in Europe that it came to life in Chicago, where in 1959 an advertising copywriter went to work and came up with the famous slogan "Put a tiger in your tank." (Courtesy of the Paterson Museum/Paterson News Collection.)

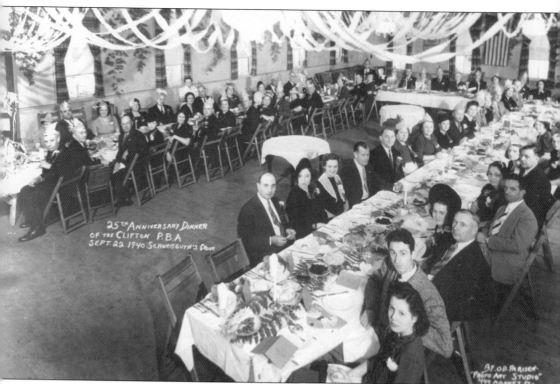

The 25th anniversary dinner of the Clifton Patrolmen's Benevolent Association was at Schweisguth's Grove on September 22, 1940. That same night, radio's Walter Winchell was talking up the story of a Clifton schoolgirl. "Dorothy Ann Wago . . . received a nice plug from Walker Winchell on the radio last Sunday night," columnist Ira Schoem wrote in this "Saturday Sweepings" column for the *Hearld-News*, "for her suggestion to him that school children be made to salute the flag with their hands over their hearts, instead of the usual outstretched arm." That salute, she felt, was too much like those of Adolf Hitler and Benito Mussolini, the columnist said. "'Let's salute with our hearts, not our hands,' was the suggestion that appealed to the famous radio reporter." (Courtesy of the Clifton Public Library.)

Three

ROAD TO BOOMTOWN

He was called "the matchbox king," the big New Jersey builder who seemingly overnight created row upon row of modest homes for the masses. His name was Stephen Dudiak, and nowhere did he outstretch his arm more than in Clifton.

"Dudiak Producing 400 in Clifton at $8,990," read the newspaper headline in June 1949, just as the 1950s were about to dawn. The community was called Maple Valley, and the 4.5-room homes—just two months after construction began—were rising on some 120 lots already.

"There is a tremendous need for housing in this price class," Dudiak said. It was a need he was anxious to fill. "He is digging an additional four foundations daily," the reporter wrote, "and framing five houses every day. An elaborate wood-working shop has been set up on the project to facilitate the large-scale operation."

Even before this venture, he had 330 homes under his belt, at Bobbink Village, on the northern end of Valley Road. Soon he was on to Ridge View Estates, a 30-acre tract along Grove Street and Route 6 (now Route 46) where he offered up 110 ranch-style homes. There the slightly larger five- and six-bedroom homes would sit on 60-by-110-foot lots and run $10,500 to $12,000.

His "economy-sized" homes also rose in Saddle River, Ridgewood, Maywood, and Cedar Grove.

In some quarters, the message did not always go over well. In Bergen County's Ridgewood, some objected to the modest scale of the houses, leaving the village's commissioners to say all they could do was try to persuade the builder to try something in a "slightly higher price level," according to press reports of the day.

As the new president of the Home Builders Association of Northern New Jersey, Dudiak laid out his vision in these words, in a newspaper advertisement to the home-buying public: "A Message to a Man with a Family. Your Greatest Security is a Home of Your Own!" It read atop this text, "Nothing else you can buy with your money, lasts so long, serves so well, gives so much value year in, year out, as your own home."

There was plenty of competition. In 1949, Saxon Woods Homes, at Barnsdale Road and Bennington Court, was a development of 4.5-room bungalows on 50-by-100-foot lots, with oak floors, open attics with two dormers, and plaster walls, just off Van Houten Avenue in the Athenia section. For $13,900, Pershing Village in Richfield offered Colonials with large closets, picture windows, and "other refinements found only in high quality homes."

In the 1950s, there were the 38 homes of Glen Oak Estates along Mount Prospect Avenue and, just off Broad Street near Van Houten, Green Meadows Estates, ranch-type homes costing $12,000.

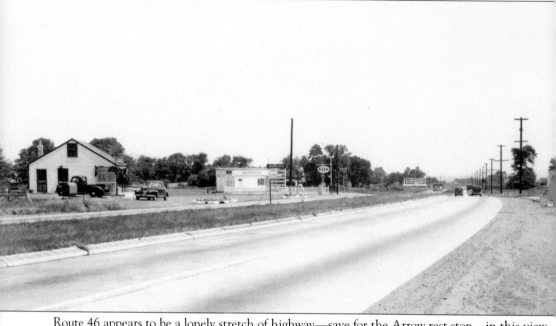

Route 46 appears to be a lonely stretch of highway—save for the Arrow rest stop—in this view looking east toward Van Houten Avenue from the Notch just after its opening. Farther east, the new highway was already having an impact. "Chris and Art Plug are building a new $15,000 garage behind their Piaget Avenue gas station," columnist Ira Schoem wrote in 1940, "setting it away back from the road to make room for the new state highway, the paving of which will be started around Oct. 20." (Courtesy of the Clifton Public Library.)

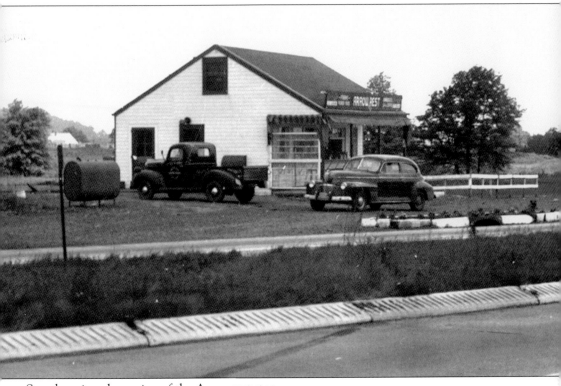

Seen here is a closer view of the Arrow rest stop.

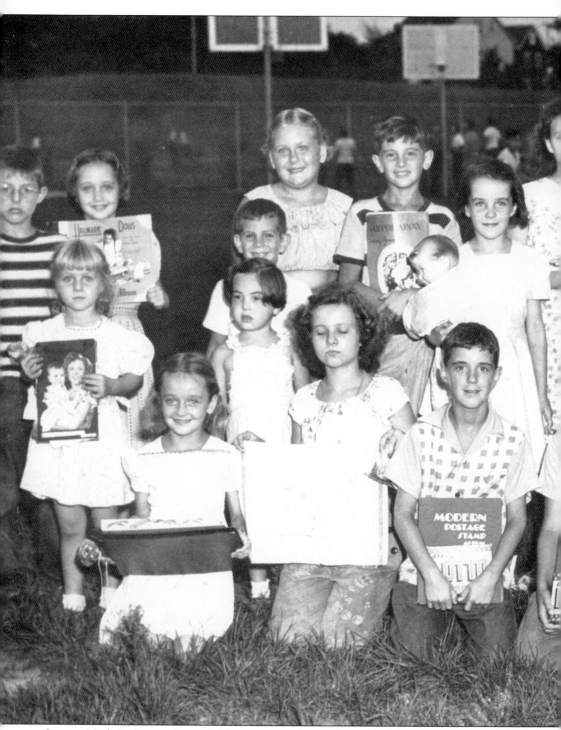

Over at Nash Park, two dozen children competed in a summer hobby contest in August 1949. Marion Zachack won first place as the most original with her movie star stamp album; Joanne Molodowitz won a prize for the most original hobby, with pictures of Washington; Albert Fulv was most creative with his key chain; Ann Kaminski and Ethel Horvath most useful with their

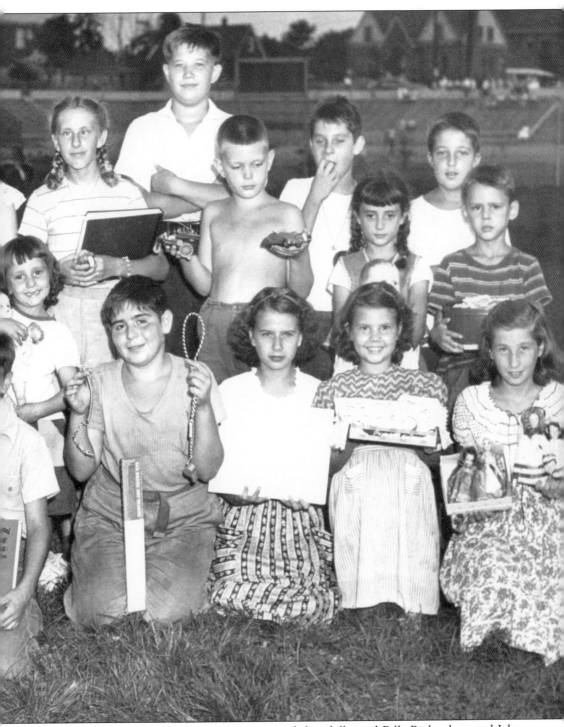

embroidery; Barbara Demchak most attractive with her dolls; and Billy Richardson and John Dornick most interesting with stamp albums. (Courtesy of the Paterson Museum/Paterson News Collection.)

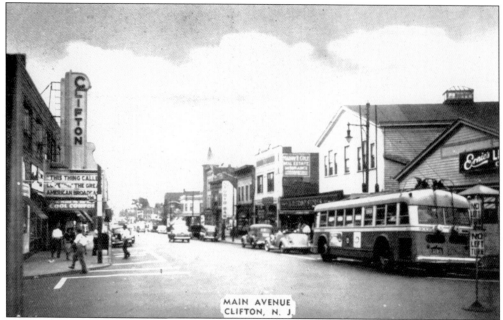

The marquee of the Clifton Theater carries the names of two of 1941's box-office draws. *This Thing Called Love*, starring Melvyn Douglas and Rosalind Russell, is the story of a wife insisting that the couple be celibate for the first three months of their marriage, just to make sure they are compatible. Yet the husband, trying all kinds of maneuvers to tempt his wife, is trumped each time. The companion feature, *The Great American Broadcast*, starring Alice Faye, is the tale of post–World War I buddies who attempt to break into the new field of radio broadcasting. Twentieth Century Fox released the nostalgia-laden picture on the 20th anniversary of commercial radio. An updated scene across from the theater, below, shows an ice-cream "Fountain Service" with "candy bar" alongside Clifton Center Pastry Shop. (Above, courtesy of the Mark S. Auerbach collection; below, courtesy of the Clifton Public Library.)

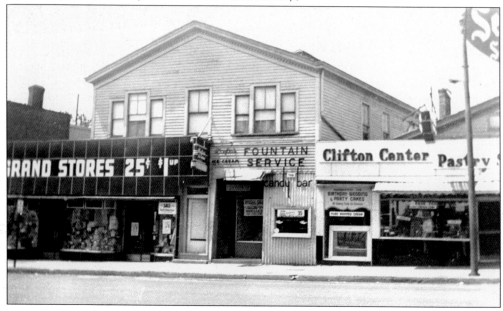

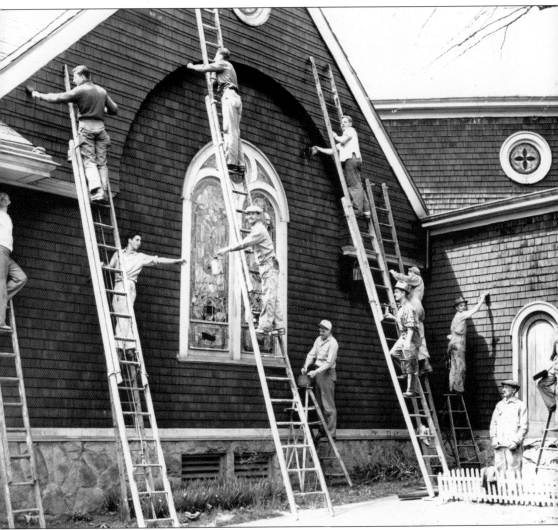

In May 1947, some spruce-up work was in order at the United Reformed Church, at First Street, just a block from Main and Clifton Avenues. Down the road just 18 months later, Clifton's newest firehouse on Madison Avenue was opened for Engine Company No. 1, which had been operating out of city hall. The cost of the new station house was $35,000. (Courtesy of the Paterson Museum/Paterson News Collection.)

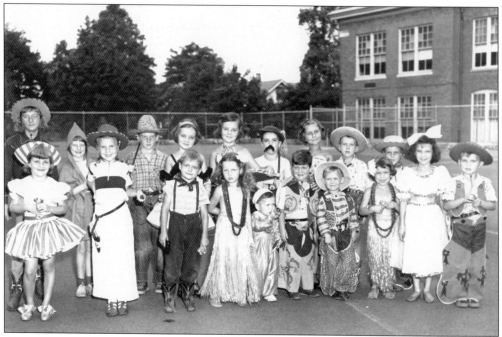

An August day in 1949 was a time of contests run by Clifton's recreation department. At School No. 5 in Albion Place, children competed and won in a costume competition with a large contingent of cowboys. That year, real estate advertisements touted neighborhood homes: "Albion Place—Fenner Avenue. Nice, sunny 2-family, steam heat, lot 50-by-150. Asking $8,900." (Courtesy of the Paterson Museum/Paterson News Collection.)

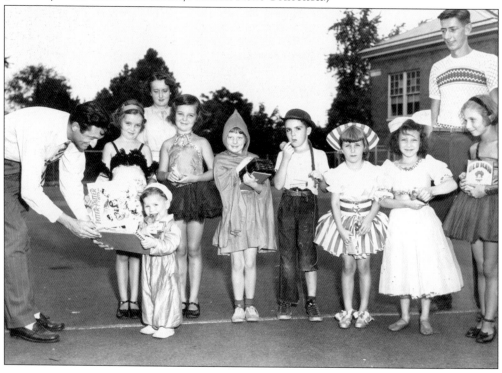

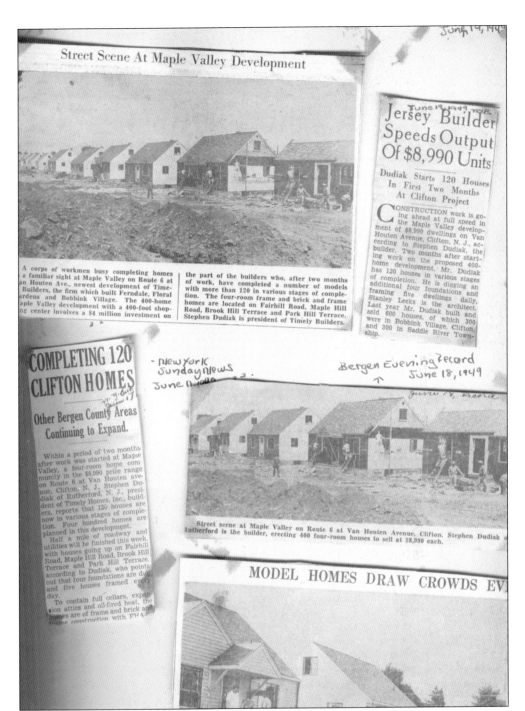

Street Scene At Maple Valley Development

June 14, 194?

Jersey Builder Speeds Output Of $8,990 Units

Dudiak Starts 120 Houses In First Two Months At Clifton Project

June 18, 1949. 19B.

CONSTRUCTION work is going ahead at full speed in the Maple Valley development of $8,990 dwellings on Van Houten Avenue, Clifton, N. J., according to Stephen Dudiak, the builder. Two months after starting work on the proposed 400-home development, Mr. Dudiak has 120 houses in various stages of completion. He is digging an additional four foundations and framing five dwellings daily. Stanley Leeks is the architect. Last year Mr. Dudiak built and sold 600 houses, of which 300 were in Bobbink Village, Clifton, and 300 in Saddle River Township.

A corps of workmen busy completing homes a familiar sight at Maple Valley on Route 6 at an Houten Ave., newest development of Time-Builders, the firm which built Ferndale, Floral ardens and Bobbink Village. The 400-home aple Valley development with a 400-foot shopng center involves a $4 million investment on the part of the builders who, after two months of work, have completed a number of models with more than 120 in various stages of completion. The four-room frame and brick and frame homes are located on Fairhill Road, Maple Hill Road, Brook Hill Terrace and Park Hill Terrace. Stephen Dudiak is president of Timely Builders.

COMPLETING 120 CLIFTON HOMES

Other Bergen County Areas Continuing to Expand.

Within a period of two months after work was started at Maple Valley, a four-room home community in the $8,990 price range on Route 6 at Van Houten avenue, Clifton, N. J. Stephen Dudiak of Rutherford, N. J., president of Timely Homes, Inc., builders, reports that 120 houses are now in various stages of completion. Four hundred homes are planned in this development.

Half a mile of roadway and utilities will be finished this week, with houses going up on Fairhill Road, Maple Hill Road, Brook Hill Terrace and Park Hill Terrace, according to Dudiak, who points out that four foundations are dug and five houses framed every day.

To contain full cellars, expansion attics and oil-fired heat, the homes are of frame and brick and frame construction with FHA

— New York Sunday News June 17, 194?

Bergen Evening Record June 18, 1949

June 18, Record

Street scene at Maple Valley on Route 6 at Van Houten Avenue, Clifton. Stephen Dudiak of Rutherford is the builder, erecting 400 four-room houses to sell at $8,990 each.

MODEL HOMES DRAW CROWDS EV

New Jersey's big builder of economy homes kept scrapbooks—such as this page on Clifton's Maple Valley—to chronicle his transformation of suburbia. One clipping in the *Bergen Evening Record* in 1949 sized him up this way: "Least ostentatious of North Jersey's great builders of homes is Stephen Dudiak. … He drives a small car and lives in a simple house without servants. … He said had he not apprenticed as a laborer, he never would have understood the problems of workmen and the needs of buyers of small homes." (Courtesy of Neil Dudiak.)

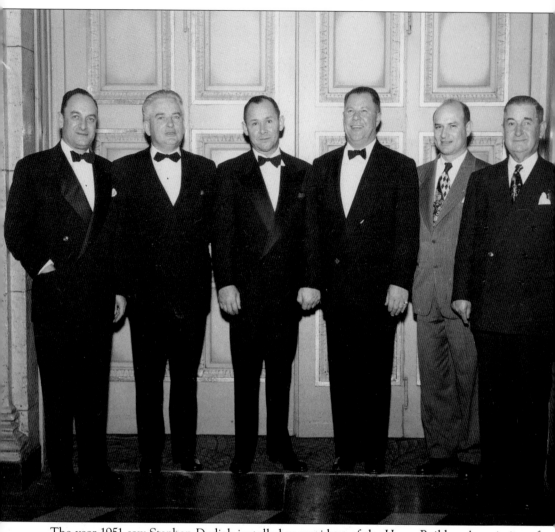

The year 1951 saw Stephen Dudiak installed as president of the Home Builders Association of Northern New Jersey as 1,400 gathered for its sixth annual dinner-dance at the Hotel Commodore in New York City. In the next few months, the oft-quoted Dudiak would take aim at local officials who opposed home-building in the "low-cost bracket" simply because it added to the rosters of the schools. "People must be housed and children must be schooled," he was quoted as saying in the March 3, 1951, edition of the *Bergen Evening Record*. "We can't shunt the young family off to some other community that's less suited. That's too much like the old police department practice of running undesirables out of town—unloading them on the next town down the line." At the dinner-dance are, from left to right, Emanuel M. Spiegel, president of the New Jersey Home Builders Association; John. F. Fitzgerald, Clifton's city engineer; Dudiak; Albert A. Stier, Clifton builder and association vice president; councilman Ira Schoem of Clifton; and Clifton police chief James N. Marsh. (Courtesy of Neil Dudiak.)

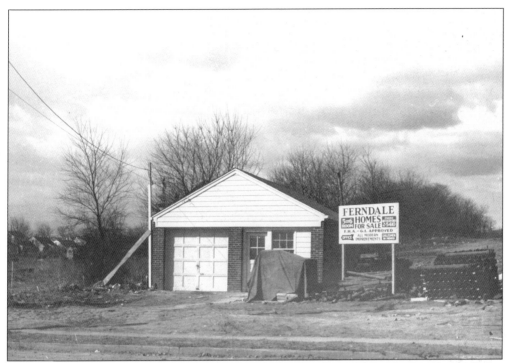

Ferndale, an early development by Stephen Dudiak's Timely Builders, was based out of this construction office at Clifton's Day Street and Fernwood Court. "Salesmen on premises," reads the sign. Before the homes went up, all that could be seen from Park Slope was plentiful land and, to the far right, Clifton's School No. 1. (Courtesy of Neil Dudiak.)

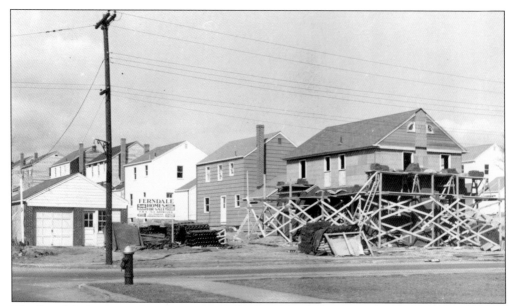

The Ferndale homes with one-car attached garages are in various stages of construction in a view seen, above, from Park Slope, alongside the sales office, and on the north side of Fernwood Court. After 1952, the new streets would be lined with the automobiles of fans of the Clifton Mustangs, whose home stadium was a stone's throw away. Neighbors could listen to the marching band, the cheers, and the announcer's voice as the Mustang gridiron champions made frequent forays into state championship competitions. Stephen Dudiak himself had interests in football, namely, as president of the Paterson Panthers of the American Football League. Yet the hope of securing a future for a professional football team headed by coach Angelo Bertelli was dashed in the 1950 season, when Dudiak was forced to disband the team. (Courtesy of Neil Dudiak.)

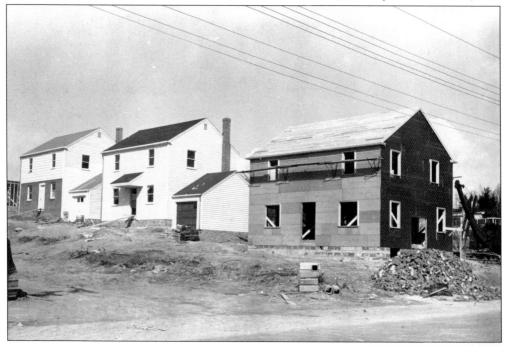

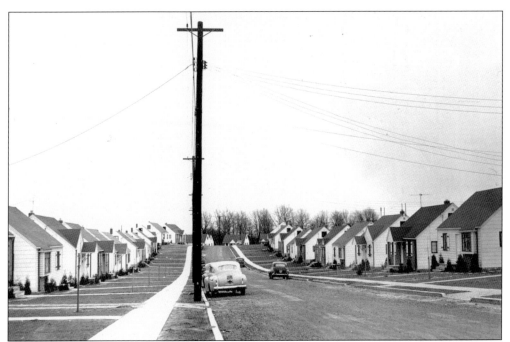

In the *Clifton Journal* of October 28, 1948, Dudiak's Timely Builders was advertising sales of its four-room homes on 50-by-100-foot lots, in a development called Bobbink Village. "In one of New Jersey's loveliest settings on Valley Road in Clifton," read the advertisement, "155 homes already sold! 50 others now available! 100 more under construction." The sales office, at 250 Edison Street, was the stopover point for prospective buyers of the $8,990 homes, pictured here in a newspaper photograph dated May 7, 1949. The 60-acre tract stood between developments called Floral Gardens and Acquackanonk Gardens. (Courtesy of the Newark Public Library.)

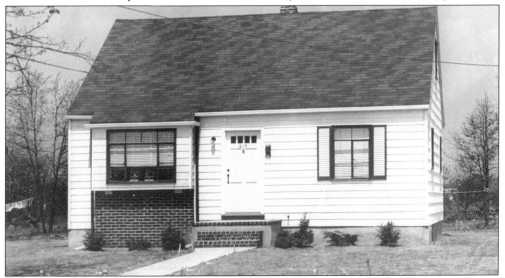

Typical of the Bobbink Village homes was this Cape Cod–style house. As soon as builder Stephen Dudiak was wrapping up some 300 homes, the April 26, 1949, edition of the *Paterson Evening News* proclaimed the groundbreaking for Dudiak's 400-home development to the south of Van Houten Avenue, east of Valley Road. The name was Maple Valley. (Courtesy of Neil Dudiak.)

- DINETTE &
- KITCHEN -
14'-2" x 8'-1"

- BATH -
5'-0" x 8'-4"

- CHAMBER -
9'-0" x 11'-0"

DWN. UP

- HALL -

C. L.

- LIVING RM. -
16'-0" x 11'-4"

- CHAMBER *1 -
12'-7" x 11'-0"

- FIRST-FLOOR-PLAN -

This sketch was used to advertise Bobbink Village in September 1948. "In one of the most attractive sections of New Jersey, these brick and frame homes have the kind of overall beauty and solid construction that make them a positive 'must' to see," touted the advertisements. For veterans, the down payment was as low as $250. The homes—priced at $8,990—featured two bedrooms and an "expansion attic." The 300-home development, at Valley Road and Edison Street, attracted families from such places as Montclair, Rutherford, Kearney, Newark, Bloomfield, and, of course, Clifton. Among the first buyers were the LaCortes, Brennans, Petersons, Lucks, McNabs, and Szabos. Stephen Dudiak built identical homes in such places as Ridgewood's East Glen Avenue, Saddle River, and the Pompton Plains section of Pequannock. (Courtesy of Neil Dudiak.)

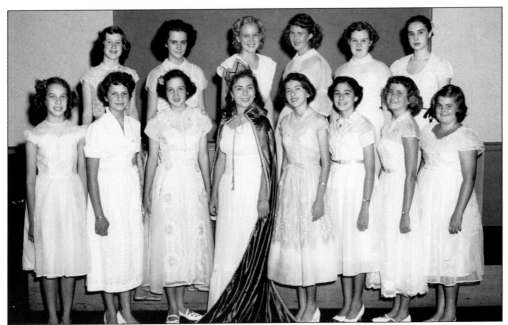

"Clifton Baby Parade Queen and Royal Family," read the September 13, 1951, headline over this picture of the court about to preside over the annual baby parade at Nash Park. The queen—Clifton High School's Ann Haroutunian—is surrounded by her princesses. Pictured are, from left to right, (first row) Barbara Nick of School No. 15, Johanna Smey of School No. 13, Janet Wolf of School No. 11, Haroutunian, Dawne Tyahla of School No. 12, Georgianne Shagawat of School No. 1, Joyce Bull of School No. 6, and Valerie Anderson of School No. 9; (second row) Eileen Swakopt of School No. 2, Gloria Marzano of School No. 4, Marlene Goldbach of School No. 13, Kathryn German of School No. 13, Jacquelyn Frantz of School No. 5, and Bette Mae Herzig of School No. 3. Not shown is Helen Damiano of School No. 7. (Courtesy of the Paterson Museum/Paterson News Collection.)

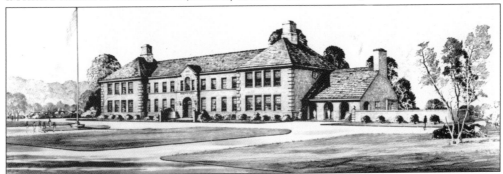

In January 1948, the growing school population in Clifton's Richfield section was in need of a larger school. The result, this sketch of the stately and classic-looking School No. 2, was designed by architects Bessell and Metz of New York City. The $619,000 school was erected on land purchased from Jacob Fishbach for $12,500, according to Marjorie Drahos, an educator who chronicled the histories of Clifton's many schools. "It has a false chimney, constructed for ornamental purposes only," she wrote. The main entrance was crafted from sandstone from the old Murray Hill Hotel in New York, she said. A steel shortage at the time resulted in some recycling. The steel from the old Wessington Stadium on Main Avenue was used to construct the school. The boom in population was so pronounced that just one month after its opening, the eighth grade had to meet in the library for want of space. (Courtesy of the Paterson Museum/Paterson News Collection.)

Angelo Bertelli—nicknamed "the Springfield Rifle" for his strong, accurate arm—was the first of Notre Dame's seven Heisman Trophy winners, the man who made the T formation click for the Fighting Irish. World War II intervened, however, and Bertelli entered the U.S. Marine Corps. It was there on Paris Island when the young marine got the big news. "We were in a Quonset hut listening to the Notre Dame game against Great Lakes on the radio," Bertelli said in a 1983 interview. "There must have been 15 of us. The Irish looked like they had won the game, 14-13, but a desperation pass beat us. I left the barracks in tears, and someone came up to me with a telegram announcing that I was the Heisman winner. I went from tears to laughter." After the war, he played with the Los Angeles Dons and the Chicago Rockets in 1946 and 1947. A knee injury ended his playing career. In 1949, he got a call from his old Chicago Rockets teammate Augie Leo, inviting him to come to New Jersey and coach the semiprofessional Paterson Panthers. The Panthers folded soon after his arrival, and he took up residence in Clifton, opening the first of a string of stores, Bertelli's Wines and Liquors in the Styertowne shopping center. (Courtesy of Michael Bertelli.)

For apartment dwellers, Clifton's Richfield Village was a good starting point for soon-to-be homeowners in 1949. That same year, advertisements enticed buyers to six-room brick and frame Colonials from $13,900 at Pershing Village on Pershing Road in the Richfield section. The advertising banner read, "Will you invest 5 minutes for a lifetime of happiness." There were other enticements. "$88 monthly for G.I.s," another advertisement read. "Special terms for civilians," it added in smaller type. Just 12 miles away in New York City that January, ground was broken for the Port Authority Bus Terminal. With so much open land, seen in the image below, Richfield was ripe for development. (Courtesy of the Paterson Museum/Paterson News Collection.)

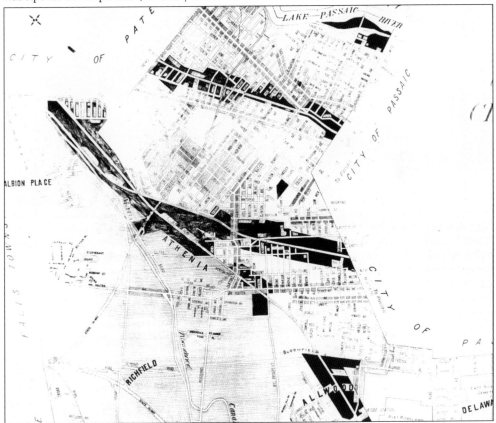

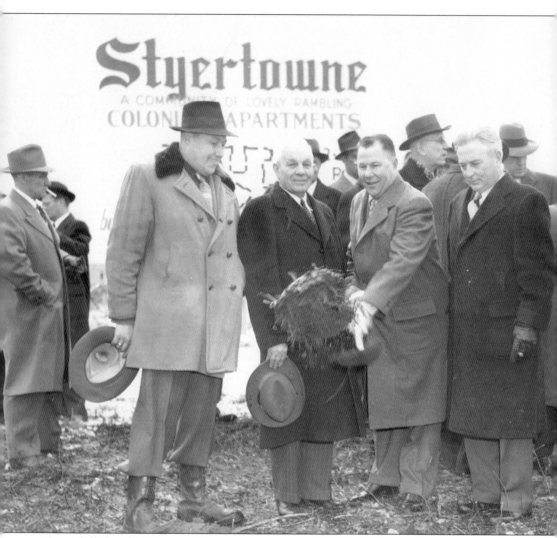

It was billed as the largest garden-apartment project in Clifton's history when ground was broken on January 27, 1949, for the 346 apartments in the Colonial style. The 11-acre swath of land—a triangle-shaped lot bordered by Allwood Road, Market Street, and Bloomfield Avenue—would be home to two- to four-room apartments for a booming population. "We hope to have the first families move in within six months," said builder Alfred A. Stier as he threw out the first shovelful of dirt. With him that day are, from left to right, Edwin B. Stier, vice president of the corporation; Jacob Kulik, building inspector; and John L. Fitzgerald, city engineer. (Courtesy of the Clifton Public Library.)

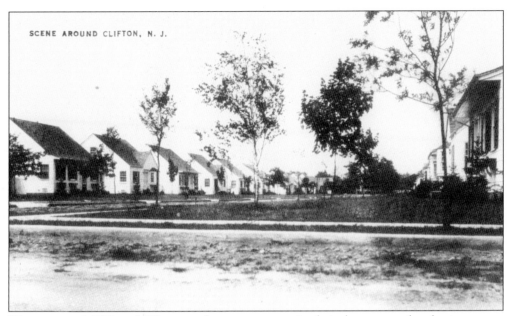

"Scene around Clifton, N.J." postcards were common in their day, as was the classic postwar Cape Cod–style home. The vernacular cottages, with their simplicity, seemed well fit for the new booming suburbs of New Jersey. "The concept of a small, 1 ½-story cottage met the mass pent-up need for new houses in the 1940s and early 1950s, while the size fit within the limits of the public's lean budgets and the nation's immediate postwar shortage of construction materials," according to a 2003 article in *Old House Journal*. (Courtesy of the Mark S. Auerbach collection.)

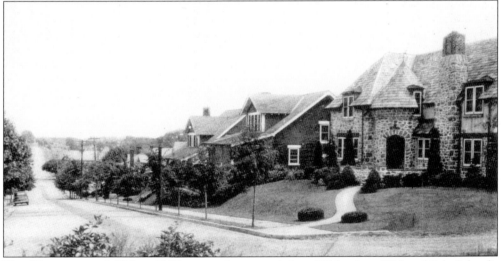

The "Scene around Clifton N.J." postcard was mailed in 1956, when Clifton High School's fighting Mustangs football team lost to Montclair 19-7 in a home game at Clifton Stadium. The news pages of the day tried to overlook the loss, playing up the $4,735 profit made from sales of tickets priced from 35¢ for students to $1.25 for reserved seating. At a November meeting, school board members asked school superintendent William Shershin to send a letter to Montclair High School coach Clary Anderson, praising him for the "clean manner" in which his team played. Gerard Hollander, the board president, then quipped, "And say we wish him no luck whatever next year." (Courtesy of the Mark S. Auerbach collection.)

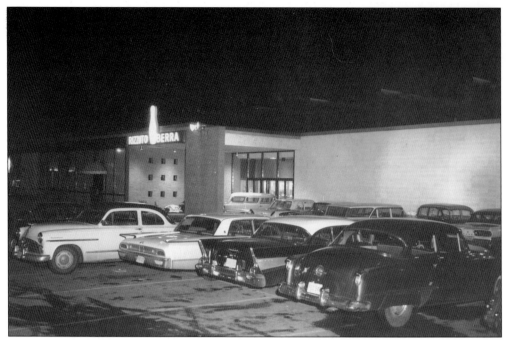

Yankee greats Yogi Berra and Phil Rizzuto teamed up to create the Rizzuto-Berra Bowling Lanes at Clifton's Styertowne shopping center, touted as America's first suburban shopping center. At the May 7, 1956, groundbreaking, they were joined by Rocky Graziano, the former world middleweight boxing champion, and Clifton mayor John W. Surgent. The illuminated bowling pin graced the front entrance to the 40-alley establishment, whose cocktail lounge was shaped like the Yankee Stadium infield. In the photograph below, Berra, second from left, and Rizzuto, fifth from left, were joined by their wives, Carmen Berra and Cora Rizzuto, and friends at the 1958 opening. They were not the only celebrities in the neighborhood on the week Berra put shovel to earth. On May 3, 1956, Rudy Vallee, the "My Time Is Your Time" crooner of three decades, stopped in for a tour at 65 Industrial South in Allwood, the home of the hair-cream maker Harold F. Ritchie Company. (Courtesy of the Yogi Berra Museum.)

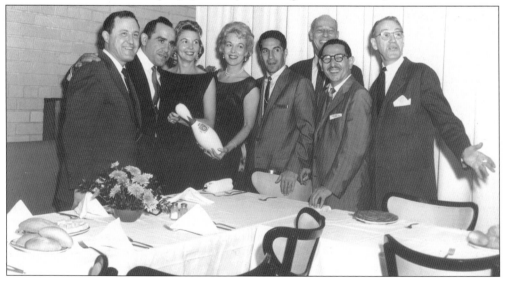

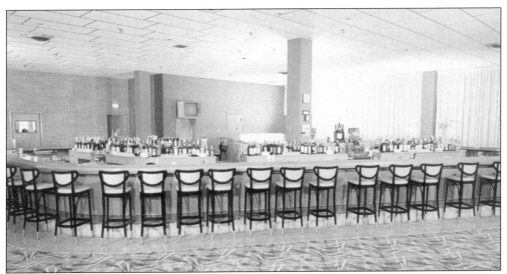

The lounge at the Rizzuto-Berra Bowling Lanes has the Midas touch, literally. It was an installation by Midas, exclusive designers of luncheonettes, restaurants, and taverns, whose New Jersey locale was on Springfield Avenue in Irvington. Lounges such as these were the first places many people got their first glimpse of color television in days when the black-and-white television still reigned in American households. (Courtesy of the Mark S. Auerbach collection.)

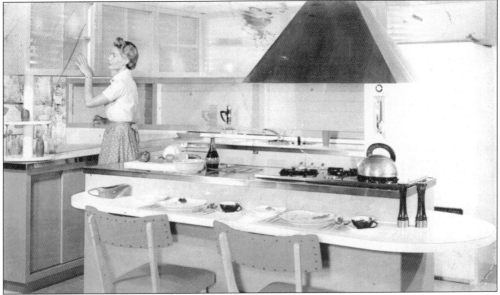

With all the new home building, such places as the Parker House on Route 46 in Clifton were selling kitchens. "This Wood-Metal custom-designed kitchen is color-styled in cinnamon, one of Wood-Metal's 'spice colors,'" reads the back of this postcard advertisement from 1956. Of course, the kitchen was not the only place for women. "Femme radio dispatcher," read a story in the *Herald-News* on December 18, 1956. "Mrs. Sally Telep, who made headlines two months ago when she presented her husband, Nicholas, with a second set of twins in 11 months, is chief radio dispatcher for her husband's 24-hour towing service." Alongside the article, the mother is pictured with her family in her 25 Grove Street home, talking over a Du Mont two-way mobile communications system. (Courtesy of the Mark S. Auerbach collection.)

By the 1950s, School No. 16, center, would open on Grove Street near the Montclair border in a neighborhood known as Montclair Heights. In the foreground is Northfield Terrace, part of a development called Montclair Vista. The homes, largely split-levels and ranches, were being snapped by the spring of 1953. "The two models exciting the most interest," read an news account of the day, "are the 'Montgrove,' priced at $17,990, and the 'Brantwood,' which sells for $19,900. The 75-by-125 foot plots are fully improved, and the site is close to all conveniences." Among the neighborhood's pioneers were the Grimms, the Simkos, the Nowatkas, and the Allens of Montclair. The development was the handiwork of Louis Corsi and Son.

Four

SHOWBAND OF THE NORTHEAST

They are introduced as the "Showband of the Northeast" and for good reason. The high-stepping Mustang Marching Band, at 160-plus members strong, carries the big sound of the Big Ten college bands.

"Now . . . with the heavy influence of bugle corps in high school bands, our sound is refreshingly different," longtime band director Robert Morgan once said in a newspaper interview.

The band, noted for forming the classic script *chs* while marching on the field, is known as a showstopper. "The band always wins," Clifton's mayor James Anzaldi could be heard saying on a day the football team lost a game.

Still, it was not for lack of trying. In the stands, the bandsmen are vocalists too, loudly singing this fight song:

The word is Fight! Fight! Fight! for Clifton High.
Let every loyal Mustang sing;
The word is Fight! Fight! Fight! for Clifton High.
Until the walls and rafters ring (Rah! Rah!)
Come on and cheer, cheer, cheer, for Clifton High
Come on and cheer until you hear the final gun.
The word is Fight! Fight! Fight! for Clifton High,
Until the game is won.

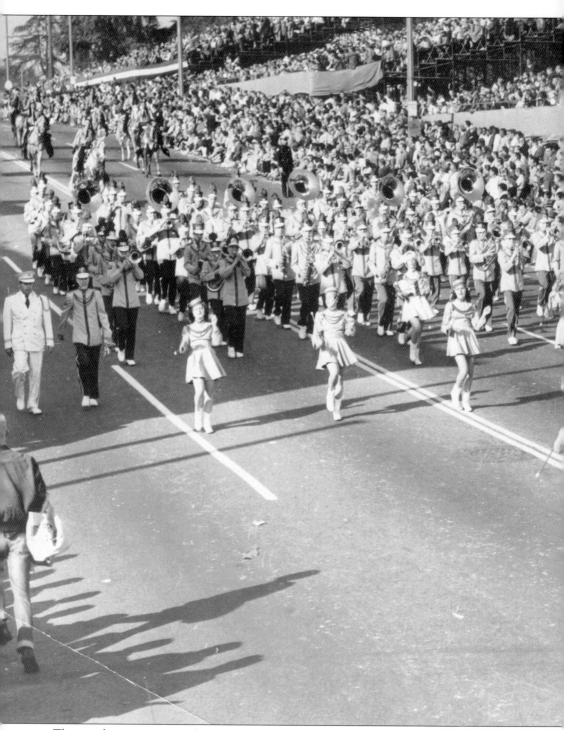

The parade route was six miles, a lengthy march in the Tournament of Roses Parade in Pasadena on January 1, 1959, that began only after a three-day, cross-country train ride endured to save on travel costs. One majorette, Patricia Retherford Peterson, recalled the trek under the watchful eyes of the television cameras beaming images home to Clifton, according to *The First 50 Years:*

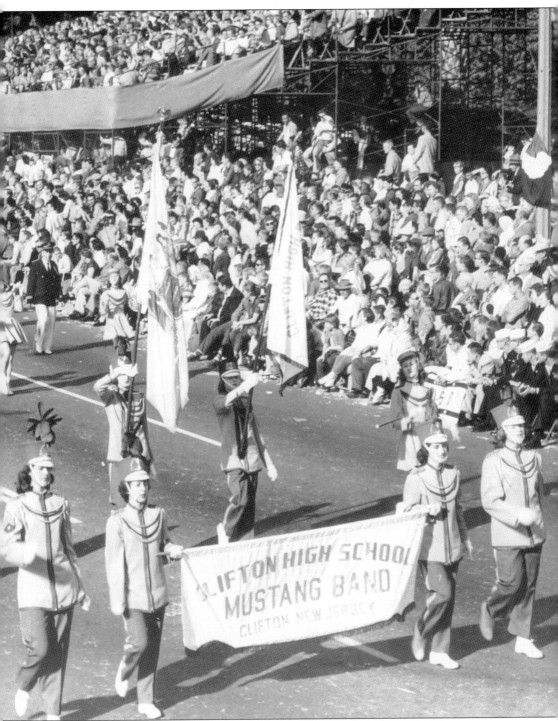

History of the Clifton High School Mustang Band, 1938–1988. They wore wool uniforms in 90-degree heat. "A lot of us did not go to the [Rose Bowl] game from exhaustion but watched the game in our rooms," she said. And those boots, they were bloodstained, she said, from bleeding blisters. (Courtesy of the Morgan family.)

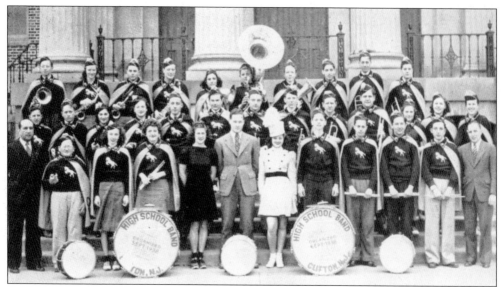

It was year number two for the Mustang Marching Band, whose new jerseys now sported the image of a mustang, in June 1940, with drum major Warren Grant standing front and center on the steps of the then high school, now Christopher Columbus Middle School. At far left is band director James C. Moscati, the "father" of the Clifton High School band. (Courtesy of the Clifton Public Library.)

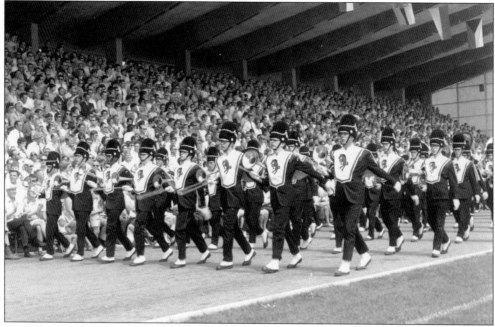

It was July 1970, and the band was on the march for a repeat performance at the World Music Festival in Kerkrade, Holland, picking up gold once again. The trek included a weeklong tour of Italy. A hero's welcome awaited upon its return to Clifton Stadium. Within weeks, the band performed a halftime show for a preseason football game between the New York Giants and Cleveland Browns. (Courtesy of the Morgan family.)

In July 1966, the Mustang Marching Band got a rousing send-off as it flew out of Kennedy International Airport en route to Europe for the World Music Festival. Once in Kerkrade, according to *The First 50 Years: History of the Clifton High School Mustang Band, 1938–1988*, it became the first American band to win two gold medals in one year (for marching and concert) and the first American band to win gold in consecutive festival appearances. The band first flew into Paris, then to Amsterdam, and took in Belgium and Germany, as well as London. Carol Ann Horton Prater, a senior clarinet player and band manager on the trip, had the restroom detail. "I spent endless evenings making sure everyone had access to a room with a bath or shower every so many days," she later recalled. "When we arrived at each stop, the arrangements were all different, so my nights of making sure no one would be 'stinky' were in vain." Back home, a congratulatory letter for the band was waiting, from Pres. Lyndon Johnson. (Courtesy of the Paterson Museum/Paterson News Collection.)

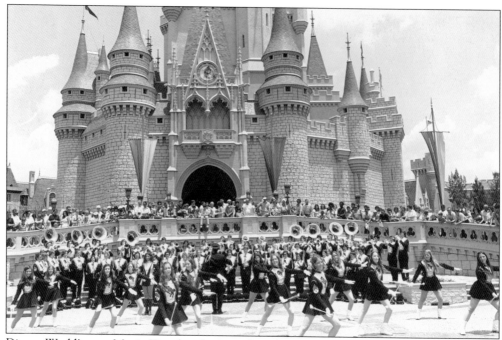

Disney World's new Magic Kingdom beckoned in the spring of 1973 as the band ventured to Orlando, where it paraded in front of the castle and performed during Robert Morgan's first full year as band director. Salt pills were at hand, given the heat, yet no one apparently fainted. (Courtesy of the Morgan family and Walt Disney Productions.)

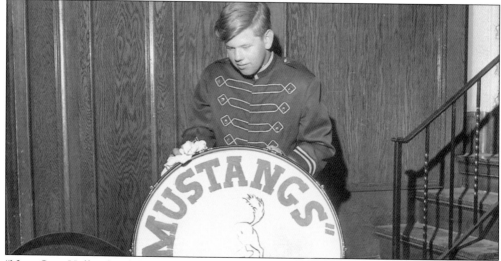

"Next Stop Holland," read the newspaper account on July 22, 1966, as the Mustang Marching Band readied for a return engagement to Kerkrade, where it won first-place honors in marching in 1962. Here a bass drummer identified as John Vande Vaarst, 17, of Van Houten Avenue readies for the trip. The drum major that year was Joan Franke, 17, of 25 Park Hill Terrace. In a few days, the 149-strong band performed a "Thank You Clifton" show ahead of its departure as a sign of thanks for those who contributed to the $72,000 needed to make the trip possible. A newsreel of the show, at Clifton Stadium, was to be played on NBC television's Channel 4 in the New York City market. (Courtesy of the Paterson Museum/Paterson News Collection.)

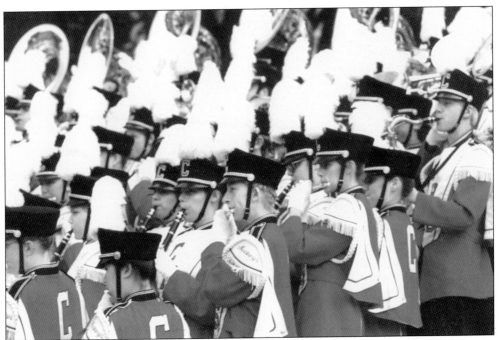

In 1996, the Mustang Marching Band was in need of uniforms, but they did not manage to find their way into the school district's budget. At a meeting of Clifton Band Parents Association, director Robert Morgan said, "We're going to raise the money." And so they did. They knocked on doors. They worked the telephones. In a matter of weeks, Clifton's dedication to its ambassadors of goodwill was evident: More than $100,000 had been raised for some 200 uniforms. On December 6, 1996, the band conducted a special thank-you concert called "Sounds of the Stadium." "You not only gave out of your pockets, you gave from your hearts," said the words in this program. In the photograph above, members of the band in their soon-to-be-retired uniforms can be seen, white gloves and spats included.

CLIFTON HIGH SCHOOL
MUSTANG Band

★ DECEMBER 6TH ,1996 - 7:30 PM ★

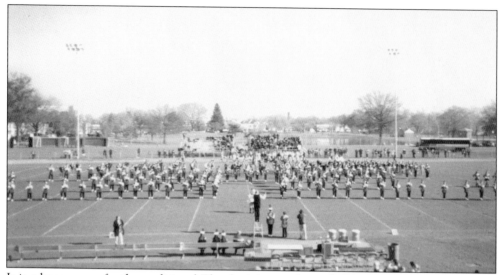

It is a home game for the traditional Thanksgiving rivalry with Passaic in the late 1990s, and alumni band members—going back decades—prepare to join the rest of the band on the field at Clifton Stadium.

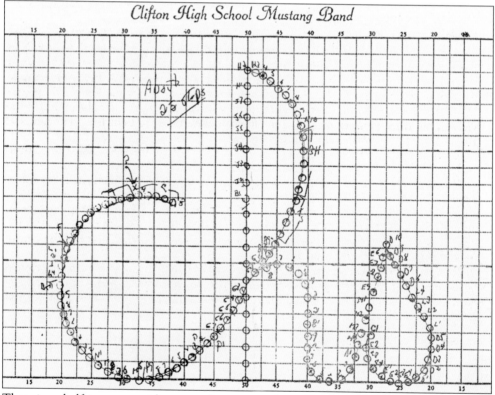

There is no halftime game without a road map, as evidenced by this chart—one of dozens—that Mustang Marching Band members have to memorize even as they played their instruments. Here is the classic script *chs*.

Five

JUBILEE

On June 5, 1967, Clifton's jubilee parade—big by any standard—was front-page news. William Power, in this dispatch from the *Paterson News* entitled "200,000 Turn Out for Clifton's Jubilee Parade," uses the widely different crowd estimates to grab the reader's attention. This was not the reporter's only brush with a parade. For many years, Power, a highly decorated World War II veteran, could be spotted marching in the annual Memorial Day parade along Allwood Road.

CLIFTON: Parade buffs by the thousands (one official said as many as 200,000) turned out Sunday to brave the blazing hot sun to watch and cheer the giant Clifton Jubilee parade as the marchers bravely made their way for over 4 miles from Allwood Road to the stadium.

More than 50 persons, most of them marchers, were overcome by the heat of the 4 hour parade and required medical treatment. The Clifton Emergency Squad and Civil Defense Units at the stadium and at other points along the way administered aid to most of the victims, but three persons, including one fireman, were taken to Beth Israel Hospital and Passaic General Hospital for treatment. None were admitted.

Although the crowd at the stadium was less than expected, the sidewalks were jammed with spectators, as many as 20 deep in some spots.

The estimates of the size of the crowd varied, depending on who made them. Police Chief Joseph A. Nee said there were over 125,000. City Manager William Holster said 150,000. Parade Director John McCallum, who directs the annual Macy Thanksgiving Day Parade, said 175,000, and Motorcycle Patrolman Elmer "The Terrible" King said there were 200,000. Take your pick. One thing is sure. It as the largest crowd in the city's history. The official population of Clifton is less than 90,000.

The effect of the heat on the marchers was brought home vividly to the stadium crowds as seven northern huskie dogs arrived pulling a sled on wheels with their tongues hanging down to the ground. As they passed the reviewing stand, one dog collapsed, panting, and refused to move until it had rested a moment.

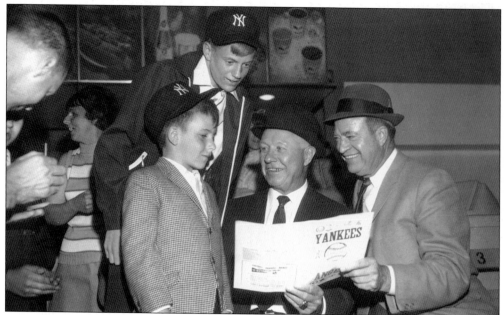

At 1967's Clifton Day at Yankee Stadium, Jack Kuepfer, 12, of Merrill Road and a boy identified as Stevig Will, 7, of Highland Avenue get a chance to meet up with some of Clifton's past, namely, members of the Doherty Silk Sox, who played alongside the silk factory on Main Avenue. There is Bennie Borgmann, 65, of Hawthorne, who was a Silk Sox shortstop from 1921 to 1927 at Clifton's Doherty Mill and then was chief scout for the Minnesota Twins. With him that day was Bill Durkin of Wayne, then 59 and a onetime team mascot for the Silk Sox. (Courtesy of the Paterson Museum/Paterson News Collection.)

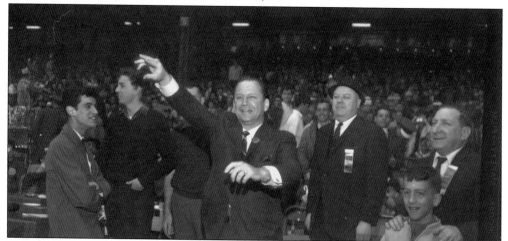

Play ball! In front of 5,000 Cliftonites at Yankee Stadium, Mayor Joseph Vanecek throws out the first ball of a doubleheader between the New York Yankees and the Los Angeles Angels. That day, Clifton children received official Yankee caps and were able to see Clifton High School's Mustang Marching Band perform between games. Vanecek's pitch, by the way, was caught by Frank Crosetti, the onetime Yankee shortstop known as "the Crow," and a player whose antics included lifting the opposing team's signs from the dugout and hiding a baseball to tag out a base runner. By 1967, Crosetti was near the end of his Yankees coaching career. (Courtesy of the Paterson Museum/Paterson News Collection.)

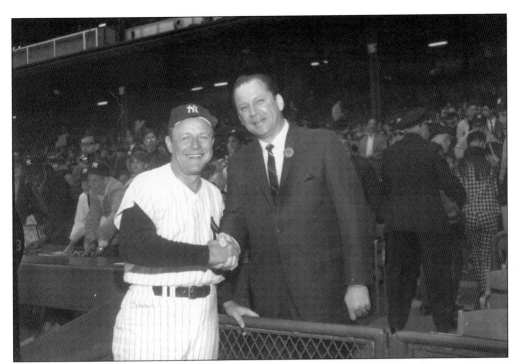

Yankees manager Ralph Houk of Saddle Brook steps up to the fence to shake hands with Clifton mayor Joseph Vanecek at Yankee Stadium in 1967. Just five years earlier, Houk, known as the "Major," replaced legend Casey Stengel as manager of the Yankees. That first year, Houk led the Yankees' most explosive home run–hitting team, led by Mickey Mantle and Roger Maris, to the pennant. By 1963, he was replaced by Yogi Berra, only to be brought back in 1966 for eight seasons, never to win another. (Above, courtesy of the Paterson Museum/Paterson News Collection.)

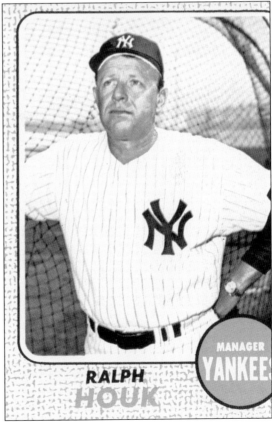

RALPH HOUK

MANAGER YANKEES

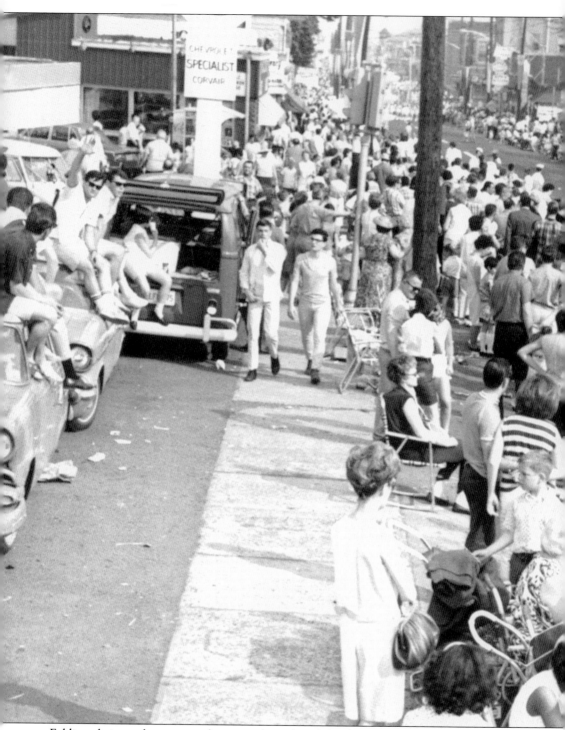

Folding chairs and cartop perches were the order of the day on Clifton's Main Avenue for the jubilee parade. That same night, for those who kicked back to watch some television, there were the Emmys. The pop singing group the Monkees won in the outstanding comedy series category, with Emmys also going to Don Adams of *Get Smart*, Don Knotts of *The Andy Griffith Show*, and

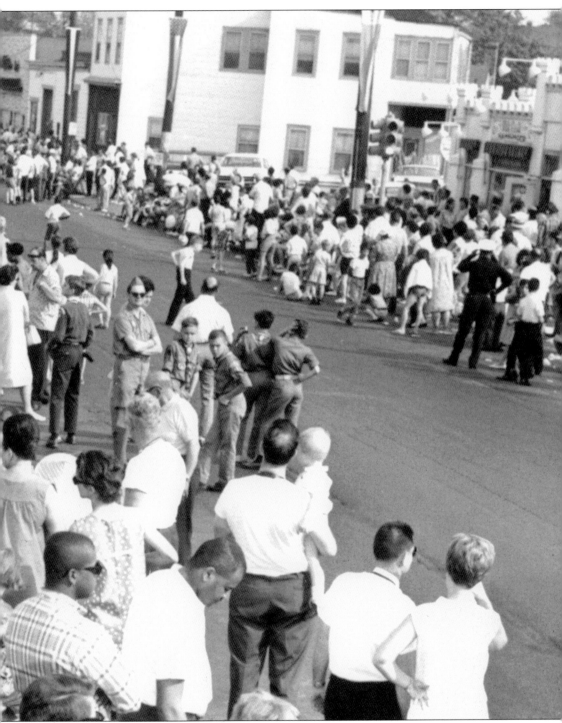

Lucille Ball for *The Lucy Show*. Within days, the Monkees, then at the top of the charts in record sales, were being supplanted by the Beatles, who had just released the album *Sgt. Pepper's Lonely Hearts Club Band*. (Courtesy of the Paterson Museum/Paterson News Collection.)

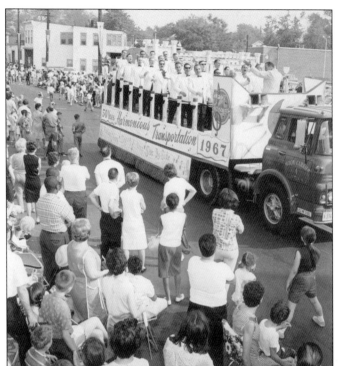

The Moon Carrier float, making its way along Clifton's Main Avenue during 1967's jubilee parade, is topped with row upon row of bow tie–wearing singers known as the Clifton Songsters. (Courtesy of the Paterson Museum/Paterson News Collection.)

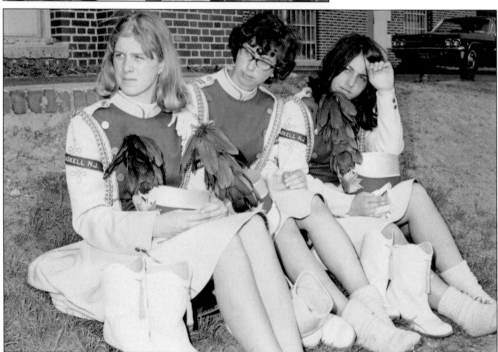

The four-mile trek of Clifton's jubilee parade behind them, these members of the Memorial Drum and Bugle Corp of Haskell, from left to right, Kathy Roberts, 15; Barb Macfie, 18; and Carol Palatucci of Wanaque, are ready for a respite. (Courtesy of the Paterson Museum/Paterson News Collection.)

Roy Schleich's family moved to Clifton in 1903. His father is credited with introducing Scouting to Clifton, starting the first troop in 1918. So Schleich, an assistant secretary to the New Jersey State Senate, was right at home when chosen to lead the jubilee committee. Here in the spring of 1967, Schleich, left, is all smiles as he shows off the city's anniversary cake at the Robin Hood Inn. (Courtesy of the Paterson Museum/Paterson News Collection.)

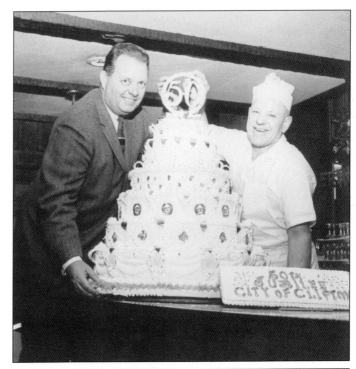

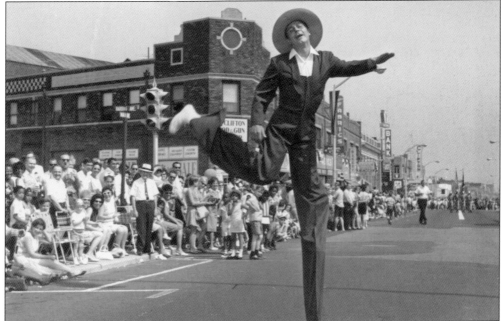

Billy Conrad of Boston stands 16 feet tall—on stilts of course—as the parade makes its way down Clifton's Main Avenue, with a glimpse of the Clifton Theater's marquee in the background. By the time the parade reached Washington Avenue, Clement Ferdinand of Oakland was there with his own personal reviewing stand, a high-above-the-crowd seat on a truck he had parked at 8:00 a.m. for about 24 friends and family. The host even provided the food: four dozen hot dogs, according to press reports. (Courtesy of the Paterson Museum/Paterson News Collection.)

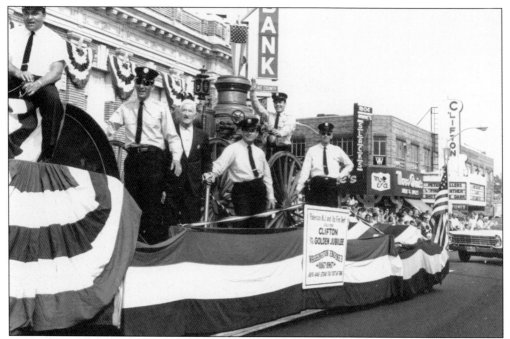

Floats came in all sizes and from all destinations. Clifton's neighbor to the north, Paterson, was represented by its mayor, Lawrence "Pat" Kramer, who while in the first of four terms waved from the back seat of a convertible along the parade route. There was also the "official entry," a float carrying Old Washington No. 3, a hand-drawn steam fire engine pumper from the Civil War era. The engine, restored in 1948 through the efforts of Harry B. Haines, publisher of the *Paterson News*, and the Paterson Firemen's Mutual Benevolent Association, was escorted by Paterson firefighters. Among them were, from left to right, Capt. Alphonse Iandoll, firefighter Joseph Parkins, retired firefighter John Hefran, and firefighters Philip Mendillo, William Fillpelli, and Robert Salmanowitz. (Courtesy of the Paterson Museum/Paterson News Collection.)

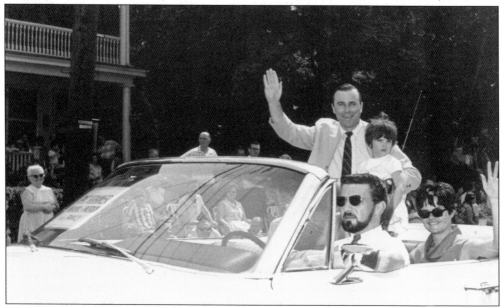

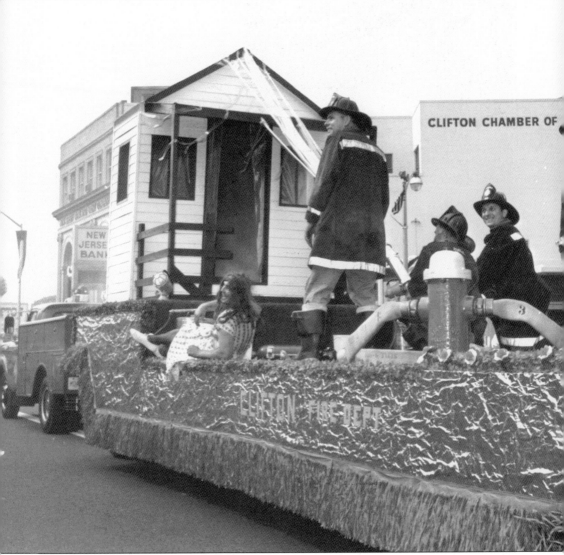

Clifton's firefighters man their float in the jubilee parade, as did others. The list of parade marchers was seemingly endless, among them Henry Fette, chairman of the parade, who rode a silver-gray horse. The fire apparatus turned a lot of heads. "A parade just isn't a parade without fire engines," wrote a *Herald-News* reporter. "Equipment used a century ago, as well as the most modern pumpers, rolled down the parade route, the sun glaring off the bright red finish and the polished brass and steel." (Courtesy of the Paterson Museum/Paterson News Collection.)

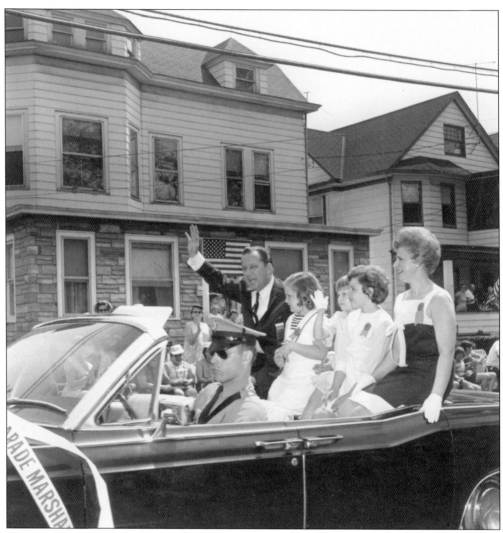

Nearing First Street along Clifton Avenue is Mayor Joseph Vanecek and his family. The parade was said to be the biggest ever assembled in the country. The assertion was backed up by John McCallum, who also directed the Macy's Thanksgiving Day Parade. The evidence was everywhere—literally. "Clifton and Main avenues were littered with paper, bottles, and the kind of stuff which you would find on the streets of New York after a hot summer night," read the news report. "And the DEP workers hope there won't be another parade like that in town for another 50 years." (Courtesy of the Paterson Museum/Paterson News Collection.)

Six

THE 1960S AND BEYOND

The opening of Clifton Senior High School attracted 12,000 sightseers. Clifton's own Frankie Randall starred with Sonny and Cher in filmdom's *Wild on the Beach*. Richard Burton, Elizabeth Taylor, and even Bozo the Clown came to Clifton, lending a hand to help children in need.

It was the 1960s.

Families dined at Burn's Country Inn. The jukebox played at Poppies. Droves flocked to Paul VI Regional for the Battle of the Bands. Students trekked to Epstein's on Main Avenue for their gym clothes. Classes surpassed the 1,000 mark at Clifton High, making the tossing of the mortar boards a scene as breathtaking as at any large American university. Some 40,000 turned out for the city picnic.

And a seven-room split-level near Robin Hood Road, in 1967, could be had for $33,500.

The peak of baby boomer adolescence was at hand. Clifton's young and old would flock, starting in 1967, to the new American mall, Willowbrook at Wayne, first to Bambergers, then to Sears, and then to Ohrbach's.

The headlines also commanded attention: "LBJ Decision Stuns U.S./President Won't Seek New Term." And grief: "Clifton Church Leaders Hold Service Honoring Dr. King." At the Allwood Community Church, Rev. Raymond J. Pontier compared the slaying of Martin Luther King Jr. to the assassination of Pres. John. F. Kennedy. "The white people have lost the one man totally committed to non-violence," he said. "It is a terrible tragedy for Americans, both black and white. I fear for the next few weeks in America."

Then there was the strange. In October 1966, thieves stole $1,000 in cash and $2,000 in checks from the violations bureau just a few feet from the police dispatcher. That same month, Clifton's curious would head to the Wanaque Reservoir for a chance at a glimpse of UFOs that made the national headlines.

"It was the brightest light I've ever seen in the sky," said one policeman. "It made square turns instead of round turns. . . . I know what I saw. No one can tell me I was looking at swamp gas."

Over on Bobbink Court, a Siamese cat named Boo Boo, owned by 13-year-old Debra Hill, was back home after running off with just about every ribbon at the Household Pet Show in New York City. "Cooling his heels," Debra said.

By the 1970s, one of the city's last rural outposts, Mary's General Store on Chittenden Road and Grove Street, would close, forever ending a frequent stopover for bicycle-riding boys dropping coins into a Coca-Cola vending machine and guzzling the soda to get the nickel deposit back on the bottle.

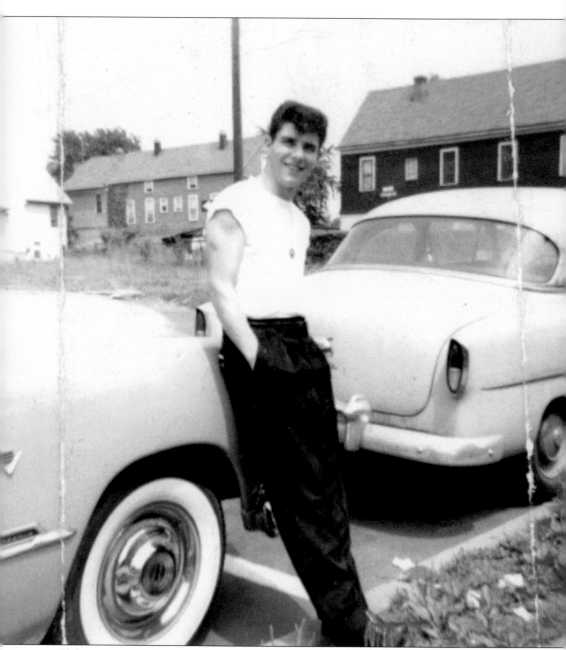

Clifton's own Frankie Randall—then just 17—leans against his 1961 Ford Victoria along Van Houten Avenue just a short while before he starred in the 1965 film *Wild on the Beach* with Sonny and Cher of "I've Got You" fame. Randall, born Frank Joseph Lisbona, would achieve fame of his own, producing seven albums and countless singles while being named three times as the Most Promising Singer of the Year. He appeared on *The Ed Sullivan Show* and *The Tonight Show* with Johnny Carson and, in 1966, was a regular on *The Dean Martin Summer Show*, along with Dan Rowan and Dick Martin, who made television history with *Rowan and Martin's Laugh-in*. (Courtesy of Frankie Randall.)

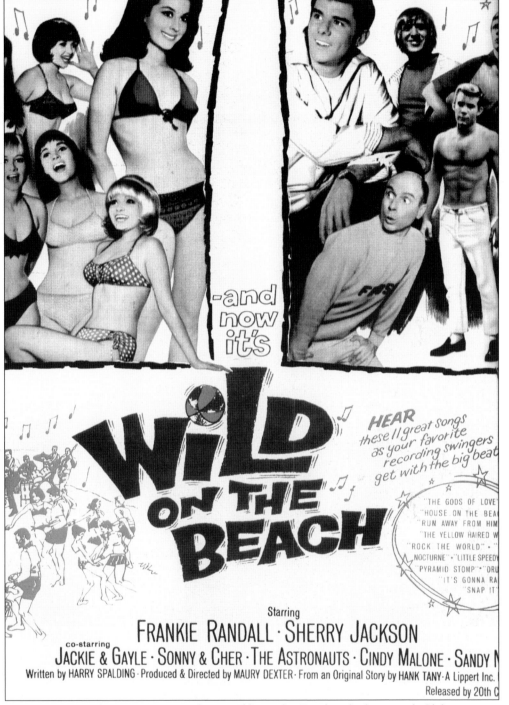

Shown here is the movie poster from *Wild on the Beach*, which starred Clifton native Frankie Randall.

Home in Clifton was 62 West Second Street, where singer Frankie Randall grew up and embarked at the age of seven on his classical piano lessons. His college career would take him to Fairleigh Dickinson University, where he received his bachelor's degree in psychology and minored in philosophy. Later Randall became a vice president at Bally's Grand and booked his old friend crooner Frank Sinatra before returning to his first love, music. Here he stands with his mother, Grace, and sister outside his West Second Street home. "I was about 9 years old in this picture, and my sister, Grace Elaine, was about 6," he said. (Courtesy of Frankie Randall.)

In a special Boston-to-Clifton trip, Bozo the Clown, also known as Frank Avruch, came in a surprise visit to see six-year-old Stevie Mokis, a leukemia sufferer, at St. Philip's Roman Catholic Church School in October 1964. It all started when the boy's mother, Providence, wrote WPIX-TV in New York to get a photograph of Bozo for one of his biggest fans. WPIX got in touch with Bozo, who taped his shows at WHDH in Boston, and the television favorite volunteered to visit little Stevie. "So when Steve Mokis walked into the auditorium at St. Philip's school and saw Bozo the Clown, he was speechless for a moment," wrote reporter Howard Ball, "but only for a moment. Then the laughter sprang forth, and as Bozo entertained, Steve for those fleeing moments was transported to that wonder world that is the province of 6-year-old boys." With him that day were some 500 classmates and his family, who lived on Brook Hill Terrace. (Photographs by Joe Gigli, courtesy of the Paterson Museum/Paterson News Collection.)

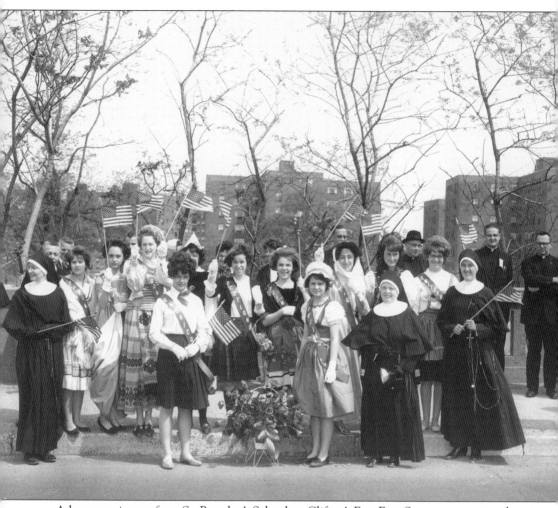

A large contingent from St. Brendan's School on Clifton's East First Street came out to cheer on Rev. James J. Navagh after he was named Roman Catholic bishop of Paterson in October 1962. St. Brendan's Roman Catholic Church has called Clifton's Lakeview section home since 1945. (Courtesy of the Paterson Museum/Paterson News Collection.)

In a sneak preview of Clifton's new senior high school, a photographer snapped these pictures on April 24, 1962. By month's end, on April 29, the empty spaces would be packed when the doors of the $5.8 million school with wings for each grade were thrown open to 12,000 visitors. At a 3:00 p.m. dedication in the 1,100-seat auditorium, the guest list was endless, including Stanley Zwier, the mayor; Arthur E. Rigolo, the architect; and J. Harold Straub, the Passaic County superintendent of schools. It was Straub who ignited the crowd, press reports said, when he called the Mustang Marching Band "the best band in the United States." The high school would become one of New Jersey's largest. "How we teach is equal to what we teach," said William Warner of the state Department of Education, "because learning is more psychological than logical. To succeed in the world today, there is a need for a change in positive action." That night, at the White House in Washington, D.C., the Kennedys gave a glittering dinner party for what was described as "the greatest collection of intellectuals" ever to gather there, among them 49 Nobel Prize winners. Pres. John F. Kennedy, making a toast, said he heard what the gathering was being called. "The President's Easter egghead roll!" he said to laughter. (Courtesy of the Paterson Museum/Paterson News Collection.)

The zebra was named Harry S. and the giraffes Ingrid and Roberto at the Clifton Quarantine Station, at Clifton and Van Houten Avenues, a stopover for animals headed to many of the nation's zoos. On July 9, 1964, the federal quarantine station made news when 22 exotic animals got their discharge papers. Among them were species of an African antelope never before brought to the United States. There were also three newborns, two striped deerlike animals known as sitatungas, and a white-eared kob. They were born either in Germany or en route to the United States via Germany. The importer, however, did state that every effort is made to avoid shipping pregnant animals. (Courtesy of the Paterson Museum/Paterson News Collection.)

In the summers of the 1960s, Camp Clifton, in Jefferson Township, was a home-away-from-home operated by the Boys Club of Clifton. The club itself had a big impact on those who walked through its doors. "There are certain places that live inside you, places you visit just by closing your eyes," wrote Jack De Vries in a remembrance written for *Clifton Merchant* magazine. In 1969, those kind of memories extended to faraway Camp Clifton. In that countryside in 1969 are, from left to right, (first row) Greg Schwartz and Pat Crane; (second row) Don Garcia, Phil Stern, Jack De Vries, Jim Hill, Jim Gonzales, and Pete Handoga. (Courtesy of Jack De Vries)

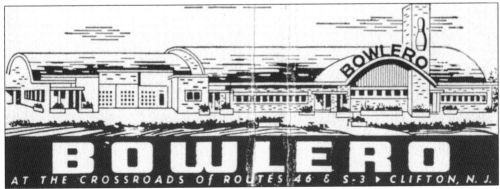

Bowlero, the bowling alley where Fette Ford is in 2006 on Route 46, featured the Bobby Wayne Trio as entertainment in the lounge in 1968. Next door was the House of Lam, which billed itself as being "Under the Same Roof as Bowlero." Its motto was "For Chinese food that is different." (Courtesy of the Mark S. Auerbach collection.)

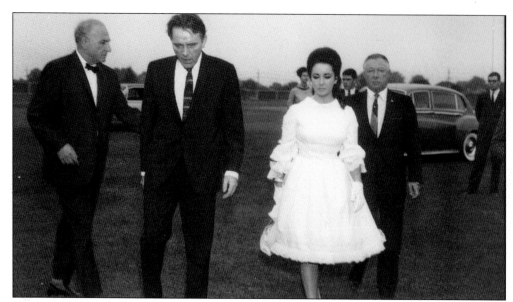

Elizabeth Taylor, who starred as a child in 1944's *National Velvet*, arrived with actor Richard Burton at Clifton Stadium in a benefit to raise money for rehabilitation therapy for a Clifton teenager, Christopher Turnham Jr., paralyzed after striking his head on the bottom of a swimming pool. The stars—stepping from a Rolls-Royce after a police escort from the Lincoln Tunnel—entered a stadium with 600 people with "brave smiles and no outward signs of disappointment," according to the *Paterson News* on that late July day in 1964. The crowd, which was small but loud, gave them a standing ovation. Tex McCrary, a radio commentator, praised the "all-American city" in a broadcast of the event, saying that "Clifton is what New York is not. Clifton is the kind of community that anticipates problems, cures them before they are in flames, the kind of town that turns out on a night like this to raise a fund to help and heal an injured, crippled boy." There was also singer Enzo Stuarti, who was performing at New York's Copacabana, and, sitting next to Mayor Ira Schoem, Kathy Dunn, former child star of Broadway's *The Sound of Music*, both of whom sang. Even the Clifton Mustang Marching Band was there, playing "May the Lord Bless and Keep You." (Courtesy of the Paterson Museum/Paterson News Collection.)

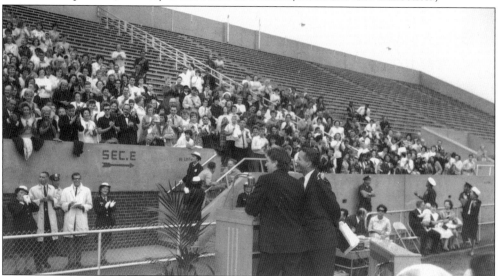

The height of the baby boom gave birth to a growing Clifton population and the need to add more pews to St. Peter's Episcopal Church on Clifton Avenue. So in 1965, the Anglican parish—in a close 50-41 vote—opted against repairs and instead decided to dismantle the c. 1899 church. Atop the old church, the 450-pound bell was gently removed until it could be placed in the new church's bell tower, topped by a huge white cross. The bell was obtained in 1935 by Rev. George Grambs, who went on several begging visits to the board of education, finally obtaining the schoolhouse bell from old School No. 3 at the next corner. On March 20, 1966, (a clear Mothering Sunday) the cornerstone was laid. "We had a great outpouring of our people, including the little ones," wrote Rev. Louis Luisa, who was then the rector. The parish marked its 110th anniversary in 2006. (Photographs by Gaston Tallet, courtesy of St. Peter's Episcopal Church.)

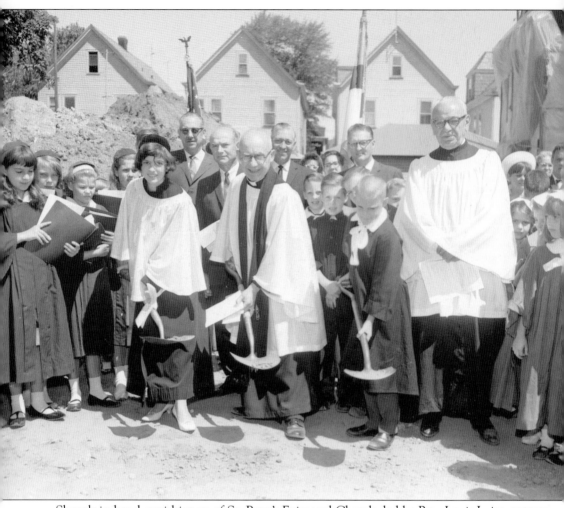

Shovels in hand, parishioners of St. Peter's Episcopal Church, led by Rev. Louis Luisa, prepare the groundbreaking for a new church in June 1965. Some were, of course, sad. "I'm sure that many parishioners of St. Peter's, Clifton, will be sorry to see the old building go," said Bishop Stark, "for I am sure that it is filled with hallowed memories. Yet we all rejoice in the progress of the parish, which demands that a new church edifice will be erected on the site so well occupied by the old." The Protestant Episcopal Church of the United States' membership over the decades has included George Washington, the first president; Betsy Ross, the famed flag maker; Judy Garland, who played Dorothy in 1939's *The Wizard of Oz*; and Edwin "Buzz" Aldrin, the astronaut who stepped on to the moon right after Neil Armstrong in July 1969. (Courtesy of the Paterson Museum/Paterson News Collection.)

William J. Bate was the top vote-getter in the municipal election of 1966, but it was Joseph V. Vanecek, seen above, who was chosen to serve as mayor by his council colleagues in a close vote that prompted Bate to challenge the decision in court. Despite this, the swearing-in commenced on May 24, 1966. "To my wife, Catherine, my appreciation for her many sacrifices. To my parents, my gratitude for their continuing inspiration," Yanecek said in an event covered by William Power, a longtime Clifton reporter for the then *Paterson Evening News*. It was a packed house at city hall on Main Avenue. At times, cheers and boos could be heard. At the oath taking (above) is Vanecek's wife, Catherine, and his three daughters (from left to right), Jo Ann, Debra Ann, and Patricia Ann. (Courtesy of the Paterson Museum/Paterson News Collection.)

He was an all-smiles Boy of the Year in May 1968. The award, from the Boys Club of Clifton, went to a then 17-year-old Vic De Luca, accompanied by his parents, Raymond and Claire De Luca. The honor came with a $300 scholarship for college expenses. The money was apparently well spent. In later life, the young De Luca became mayor of Maplewood, the Essex County community that received national accolades as one of the "Best Places to Live" in a *Money Magazine* write-up. A decade later, in September 1979, the teen center at the Boys Club is still in good use, as seen in the picture below from *Paterson News* photographer Don Smith.

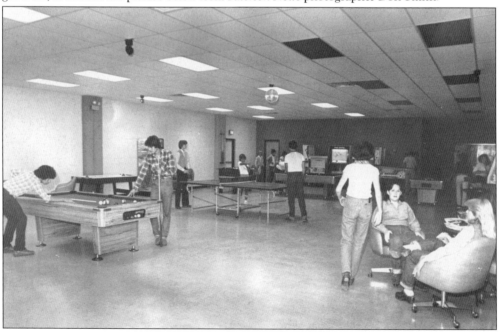

The cornerstone was laid in 1968 for Paul VI Regional, which was then Clifton's new Roman Catholic high school on Valley Road. The dedication, seen below, came on April 28, with Bishop Lawrence Casey officiating months after the school first opened to a freshman class of 240 boys and girls. "If such schools were necessary in the past to protect the simple faith of the immigrant children who attended them, they are even more necessary now," he said. Playing at the Allwood theater that month was the movie *Where Angels Go . . . Trouble Follows*, the comedy portraying Rosalind Russell as the mother superior of St. Francis teen-angels embarking for a youth rally in Santa Barbara. By 1971, Paul VI's high school yearbook offered a glimpse of the school that rose on the site of the old Great Notch Nursery Market. "Skeletal frames rose up to herald a new building, and the painful process of being born turned into the joy of being alive," the yearbook said amid pictures of students peering into a new classroom. Among the students pictured in the yearbook were Daria and Shelia Finn, two of the daughters of Patrick and Joan Finn of Janice Terrace in the Montclair Heights section. Patrick Finn was a cameraman in New York City for the long-running CBS daytime soap opera *Love of Life*, and his wife became a writer-editor for the *Montclair Times*. (Courtesy of the Paterson Museum/Paterson News Collection.)

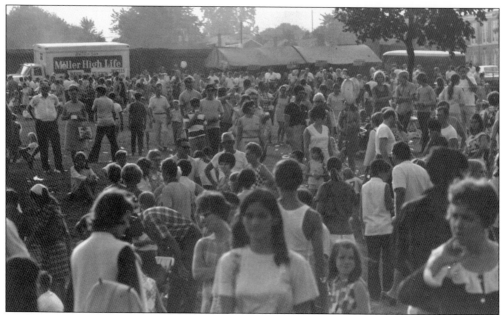

On September 7, 1969, Clifton's city picnic—then called the third annual Country Caper—attracted a record crowd of 40,000, with an end-of-the-evening showstopper of fireworks at Main Memorial Park. In the crowd that day was Helen Meyner, wife of Robert Meyner, who had served as New Jersey's governor. Robert Meyner, a Democrat who served as governor from 1953 to 1962, had returned to private practice, only to gain his party's nomination for governor in 1969. He lost that November to William T. Cahill, a Republican. Meyer's wife, the former Helen Day Stevenson, was a distant cousin of Adlai Stevenson, the Democratic Party's presidential nominee in 1952 and 1956. That picnic day, she purchased a balloon from the Clifton Girls Club stand. (Courtesy of the Paterson Museum/Paterson New Collection.)

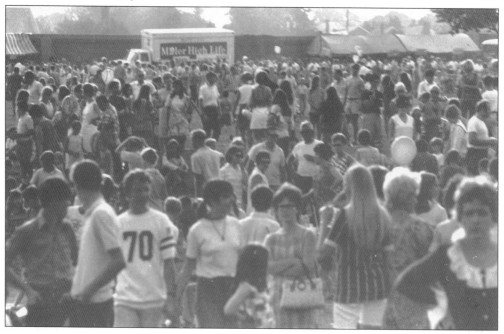

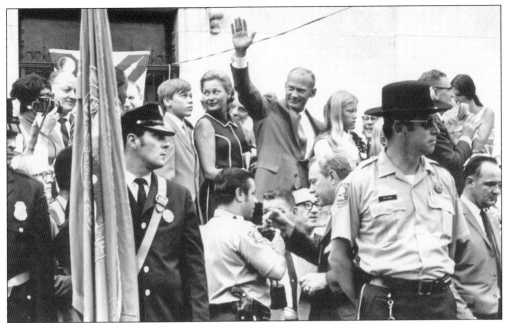

Just a few miles south of Clifton, Edwin "Buzz" Aldrin, "Montclair's Man on the Moon," came home to a hero's welcome on Saturday, September 6, 1969, just weeks after his historic walk on the lunar surface. Thousands of people, including folks from neighboring Clifton, lined Bloomfield Avenue for the motorcade. Here he extends a hand to the crowd, with his wife, Joan (originally from Ho-Ho-Kus), and behind her, their son Michael. Their daughter, Jan, is in front of the astronaut. Their youngest son, Andrew, asked to be excused to compete in a Little League football contest in Nassau Bay, Texas, that night. A love of football apparently ran deep in the family. Aldrin, who decades later would visit his old elementary school, Edgemont School, while sporting a Buzz Lightyear necktie, played football under the famed Clary Anderson. "The greatest adventure of my life," Aldrin said in 1969, "was playing football and running track in Montclair High School in 1946." (Photographs by Joe Gigli, courtesy of the Paterson Museum/Paterson News Collection.)

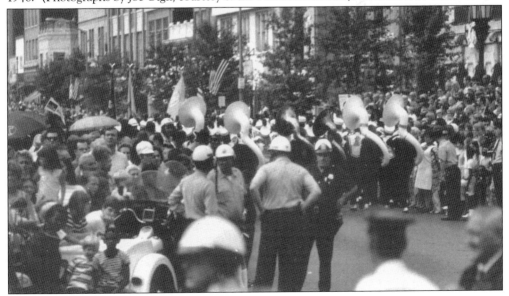

"The legend. The leader. The diner." is how the Clairmont on Route 3 westbound in Clifton billed itself. "A Jersey landmark—known and talked about," read the pitch on its postcards. Yet the diner passed into folklore itself, replaced by a Honda dealership. Not before, however, Episode 14 of HBO's *The Sopranos* was filmed there. Caught in the lens at the diner, which was then already closed, was the passing traffic. (Courtesy of the Mark S. Auerbach collection.)

The Red Chimney, on Route 3 westbound just before the Bloomfield Avenue exit at Styertowne shopping center, touted "the best in charbroiled burgers, franks, steaks and cold beer." (Courtesy of the Mark S. Auerbach collection.)

For decades, Jade Fountain's famous Yum Cha, the all-you-can-eat Chinese smorgasbord, was a big draw for Clifton families who ventured to the River Road location.

High atop a hill in Clifton's Montclair Heights section, Vincent's Hilltop Villa offered seating for up to 55 people and, in places, incredible views of the New York skyline. Next door sits the monastery, visible atop the hill from the surrounding area. In the early 1970s, onlookers would stand atop the nearby field, high above Route 3 eastbound, for a vista of the twin towers of the World Trade Center rising floor by floor out of the Manhattan skyline. Years later, on September 11, 2001, people arrived in droves as smoke billowed from the burning skyscrapers, hit by jetliners commandeered by terrorists. (Courtesy of the Mark S. Auerbach collection.)

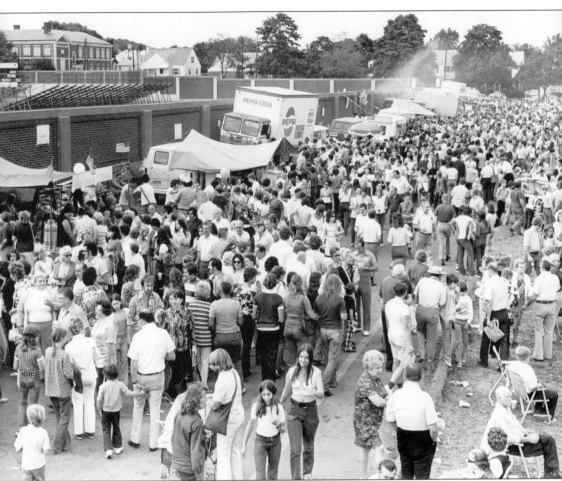

Zero in on the crowd, and the year reveals itself: bell-bottoms and hair concealing the ears are clearly visible. The date was September 9, 1973, and Clifton's annual city picnic was in full swing with an estimated 35,000 people coming out as the new school year was just beginning. It was a time to get reacquainted, especially by the food alley alongside the stadium, with School No. 1 in the distance. It being an election year, Brendan Byrne, a West Orange native and Democratic candidate for governor, was in the crowd pressing the flesh ahead of his November win. "Near perfect weather," touted the newspapers. (Courtesy of the Paterson Museum/Paterson News Collection.)

Modeling was a way of life for the four children of Rev. Earl Modean of First Lutheran Church and his wife, Marcia, during the 1970s. Perhaps the best known of the clan was Jayne Modean, far right, who found herself on the cover of *Seventeen* several times in 1977. She went on to appear in 1987's *House II: The Second Story*, as well as in such television shows as the pilot for 1984's *Street Hawk*. She also had appearances on such series as *Trauma Center* (as Nurse Hooter), *Cheers*, and *Full House*. Earlier Jayne, who learned to sew from her mother, was traveling aboard to compete—and win—sewing competitions. From their home on Wester Place, the Modean siblings, including son Paul and sisters Nancy, top, and Kathy, were often dispatched to Manhattan for modeling assignments. There in the late 1960s, young Paul Modean could be spotted on large posters in the New York subway, sporting a huge bow tie and holding a rye sandwich. "You don't have to be Jewish to love Levy's" was the well-known advertising slogan of the day. (Courtesy of the Modean family.)

Clifton's very own cover girl, Jayne Modean, could be spotted not just on *Seventeen* magazine but on the front of *Esquire*, for a story on the best and worst of college. But even before that, she could easily be spotted on the cover of *American Girl* wearing her Clifton cheerleader uniform. Jayne graduated with Clifton Senior High School's class of 1975. (Courtesy of Jayne Modean.)

At Woodrow Wilson Junior High School in 1969, students got to sign on the autograph page in the yearbook, called the *Dialtone*. In that class farewell, the color guard gathered in the gym for this picture, featuring, from left to right, Eileen Murray, Joyce Delp, Judy Lenaz, Kathie Buttner, MaryAnn Curtin, and Diane Dugan. The yearbook made note of the very fresh events of American history: the assassinations of Martin Luther King Jr. and Sen. Robert F. Kennedy and the Chicago clash between police and protestors at the Democratic National Convention. "This is 'The '69 story,'" read the introduction. "Though we are not a disadvantaged community, we are aware of the problems and issues that exist on a local, national, and international level. . . . In a world filled with problems and conflicts, our school represents a certain strength and stability to us."

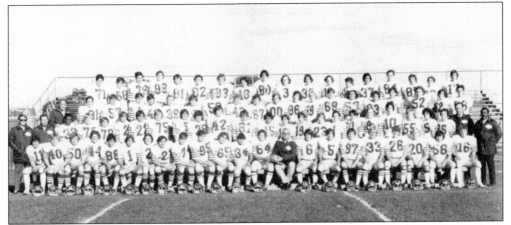

Big team, big winners in 1973, the undefeated Fighting Mustangs under coach William Vander Closter won the Group IV state championship. The Mustangs outscored their opponents 329-20. "Coach Vander Closter considered the season to be a rebuilding year, but instead found that his team was ranked No. 1 in the state," according to Clifton Senior High School's yearbook, the *Rotunda*.

At nearly 1,000 graduates, Clifton High School's class of 1973 had no shortage of who's who types. Still, only half turned up to have their picture taken for the school's yearbook, the *Rotunda*. That year, Rich Baldanza, whose arm is on the center handrail, was the most popular. He was joined that day by, among others, Ann Marie de Leeuw, the class flirt, and Wendy Keystone, the most talented. About 15 classmates did not make the picture, among them Janet Mullin, the class wit, and those who won in the best-looking category, Paul Tyhala and Debbie Macejka. In 2005, the class of 1973—part of the "don't trust anyone over 30" generation—gathered for a party at the Bethwood in Totowa as its members turned 50. This party (and subsequent ones) was organized by classmate Lori Struck.

Red bows grace the dresses and lapels of young people at a confirmation at St. Peter's Episcopal Church on Clifton Avenue around 1975. The church was then under the stewardship of Rev. Carl Nelson, left rear, whose decadelong tenure at the Anglican parish began in late 1969. Soon after his arrival, the church's parish hall became a hot spot for teen dances. One of the bands that played there, the Brats, became a local legend. (Courtesy of St. Peter's Episcopal Church.)

The Botany Village Outdoor Festival on September 29, 1979, brought out Mary Nevin Green of Clifton to the historic east end neighborhood, the centerpiece of which is Sullivan Square. The locale was the home of some of Clifton's best-remembered businesses, including Maria's Ravioli and the ever-present Damiano's Pharmacy. A hundred years earlier, the place was on the verge of attracting such textile makers as Botany Worsted Mills (1889), Forstman Wollen Company (1904), and Samuel Hird and Sons. Clifton's Hird Park, at Clifton and Lexington Avenues, takes its name from its benefactor, Samuel Hird. (Courtesy of the Paterson Museum/Paterson News Collection.)

Louise Friedman appears as a caricature in a campaign card in 1978, when she finished fifth in a field of 18 to win reelection to Clifton's city council. The election, during which 44 percent of Clifton's 39,810 registered voters went to the polls, was less kind to Mayor Frank Sylvester, whose eight-year tenure would come to an end. The mayoral victory went to Gerald Zecker of McCosh Road, who would later go on to the New Jersey State Senate. (Courtesy of the Mark S. Auerbach Collection.)

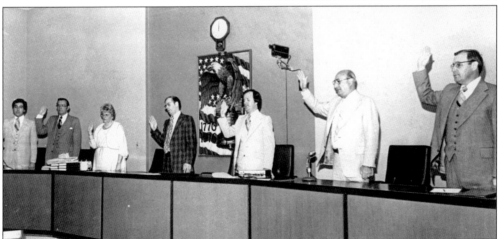

With hands raised, Clifton's newly elected council is sworn in on May 23, 1978, with Zecker, then a 36-year-old insurance company field representative and Montclair Heights resident, taking the helm as mayor. One of his first acts: all citizen complaints would be cataloged and presented at each council meeting. "So that they will not be lost in any maze of bureaucracy," Zecker, fourth from left, was quoted as saying in the *Herald-News*. Zecker was nominated for the mayor's post by young Jim Anzaldi, the 28-year-old surprise victor in the race for seven council openings. "The results showed," Anzaldi said, "they wanted young guys with clean images." Come 2006, Anzaldi, far left, was elected to an unprecedented fifth term as Clifton's mayor. (Photograph by Mike Riccie, courtesy of the Paterson Museum/Paterson News Collection.)

It was all part of a concerted effort to create housing for Clifton's seniors, and it carried the name of Renaissance Village. One of its chief engineers was Rev. Earl Modean, the longtime pastor at First Lutheran Church at Grove Street and Van Houten Avenue. (Above, courtesy of the Paterson Museum/Paterson News Collection.)

Main Memorial Park was the frequent locale of visiting circuses during the summers of the 1980s. In 1985, the Great American Circus came with a headliner by the name of Tiny Tim, the ukulele-playing, falsetto-voiced singer whose "Tip-Toe Through the Tulips" became a nationwide hit in 1969. For Tiny Tim, who in the 1960s appeared on *The Ed Sullivan Show* and *Rowan and Martin's Laugh-in*, it was a one-season gig in a career with its share of peaks and valleys. In the late 1960s, he was married to 17-year-old Miss Vicki on Johnny Carson's *The Tonight Show*, in front of a television audience of 40 million. The entertainer, who road atop an elephant in the Clifton park, died in 1996 after suffering a heart attack on stage. (Photographs by Don Smith, courtesy of the Paterson Museum/Paterson News Collection.)

In a pre-Halloween visit to Clifton School No. 3 in 1984, Clifton mayor Gloria Kolodziej spends a moment with Kathleen Stier, a second-grader, and McGruff the Crime Dog, dressed as a ghost, for a chat about safety. Kolodziej would become a pillar on Clifton's city council, serving well into the 21st century. (Photograph by Mike Riccie, courtesy of the Paterson Museum/Paterson News Collection.)

The battle lines were just being drawn for the presidential race of 1984 when Joan Mondale, the wife of soon-to-be Democratic presidential nominee Walter Mondale, in late May stopped in to greet residents of the Daughters of Miriam home in Clifton. Mondale, who was vice president under Pres. Jimmy Carter in 1976, was embarking on an uphill battle against Republican Ronald Reagan, known for his personal charisma. But Mondale was not pulling punches in his acceptance speech. "What we have today is a government of the rich, by the rich, and for the rich," he said. "First, there was Mr. Reagan's tax program. What happened was, he gave each of his rich friends enough tax relief to buy a Rolls Royce—and then he asked your family to pay for the hub caps." Mondale was defeated in a landslide, losing every state except his home state of Minnesota. (Photograph by Mike Riccie, courtesy of the Paterson Museum/Paterson News Collection.)

"OUR UNCLE JIM — ALL THE WAY READY TO SERVE YOU EVERYDAY"

RE-ELECT
JIM ANZALDI
CLIFTON COUNCIL
MAY 11, 1982

Jim Anzaldi's reelection campaign drew on his extended family in his campaign for a Clifton City Council seat in 1982. In 1994, he was reelected with the largest percentage of votes in Clifton history, and in 2006, he was elected to his fifth term as mayor. On December 3, 1983, Anzaldi, seen below and disguised as Santa Claus, greeted Erin Burke, eight months, in Clifton's Botany Village. (Right, courtesy of the Mark S. Auerbach collection; below, courtesy of the Paterson Museum/Paterson News Collection.)

Burns Country Inn, which operated from 1958 to 1984, was a big draw for family gatherings and dining by the fireplace. There Harry Burns Jr. would be the ever-present host of the restaurant at Valley and Robin Hood Roads. The inn is shown here after a later renovation, standing in front of the old Burns Country Inn antiques shop in the barn out back. The barn was demolished long ago; today the inn is the Alexus Steakhouse. (Courtesy of the Burns family.)

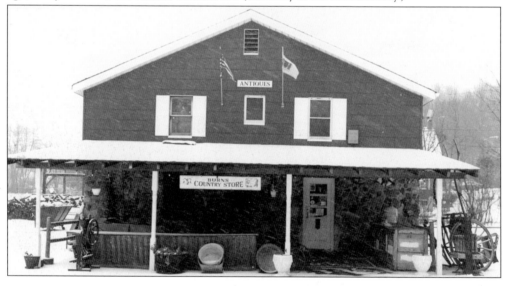

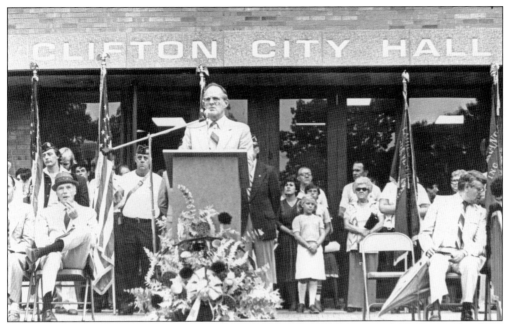

There was concern downtown about Clifton's seat of government moving to a new locale at 900 Clifton Avenue, leaving the old one behind on Main Avenue. "We're trying to create a climate so that people want to come here to shop," said Jay Grossman, who was then the president of the Main Mall Business Association. "But if people start vacating the area and we start losing business, it has a snowball effect." Just a few weeks later, in the summer of 1980, Clifton unveiled its new city hall, with U.S. representative Robert A. Roe taking to the podium. (Above, photograph by Don Smith, courtesy of the Paterson Museum/Paterson News Collection.)

Just days after Christmas in 1984, an apparently new remote-control jeep gets a workout at the 11-acre Albion Park with, from left to right, the following: Joseph Bison, 7; Chris Wagner, 11; Joseph Rodenbaugh, 9; Sean Geerlof, 9; Peter Geerlof, 7; and Robert Bisone, 9. Some of the big box-office draws that year were *Ghostbusters* and *Indiana Jones and the Temple of Doom*. In a few months, 1985's *Back to the Future*, starring Michael J. Fox, would be pulling in movie audiences. (Photograph by Phil Lanoue, courtesy of the Paterson Museum/Paterson News Collection.)

Clifton's 20-acre Weasel Brook Park, which has unique features including regulation-size horseshoe pits and the resulting championship matches, makes way for another diversion in February 1985, when John Bennett, 11, of Clifton opts to feed the ducks and geese. The park was dedicated on July 15, 1940. The raging waters of its storm tunnels can be deadly and have received write-ups in the magazine *Weird New Jersey*. (Photograph by Joe Gigli, courtesy of the Paterson Museum/Paterson News Collection.)

Clifton's football team practices drills in the rain at Memorial Field on October 1, 1984. (Courtesy of the Paterson Museum/Paterson News Collection.)

Santa Claus lands in a helicopter to greet Clifton children on December 10, 1983, in this picture by photographer Phil Lanoue. That season the holiday box office draws were MGM's A Christmas Story, the story of a young boy named Ralphie who in the 1940s tries to convince his parents that a Red Rider BB gun would make the perfect gift for him. Also that year, Disney reissued The Rescuers. (Courtesy of the Paterson Museum/Paterson News Collection.)

These aerial photographs, shot in April 1967, give different views of a changing Clifton landscape. (Courtesy of the Paterson Museum/Paterson News Collection.)

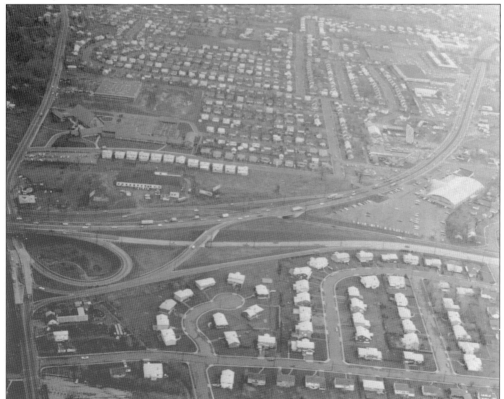

In the summer and into the autumn of 1984, Clifton, acting against the advice of its own attorney about the outcome, repeatedly went to court to prevent the destruction of the 100-foot-high namesake cliffs atop a ridge on Garret Mountain. "Our objective is still to see that the mountain is not destroyed," said Mayor Gloria Kolodziej. In court papers filed against the Little Ferry Asphalt Corporation, attorneys argued that Clifton would suffer "irreparable" harm if the cliffs were demolished because it would permanently change the contour of the land. To Sam Monchak, the city counsel, the cliffs would come down eventually. "Someday the land is going to be developed," he was quoted as saying, "and if it is developed, the cliffs will come down." The city lost the so-called "Battle of the Cliffs," and a peak of the cliffs is seen here from the rectory of St. Philip's Roman Catholic Church on Valley Road. (Courtesy of the Mark S. Auerbach collection.)

The year was 1990, and field day activities are in full swing at Holster Park, alongside School No. 16 in the Montclair Heights section. Field day activities, which were a tradition at Clifton's elementary schools, are typically run in June, as the school year wanes. Here longtime Clifton teacher George Decker offers some last-minute advice to his young charges. That very month, Pres. George H. W. Bush broke his 1988 campaign pledge of "no new taxes," accepting tax enhancers to reduce the budget deficit.

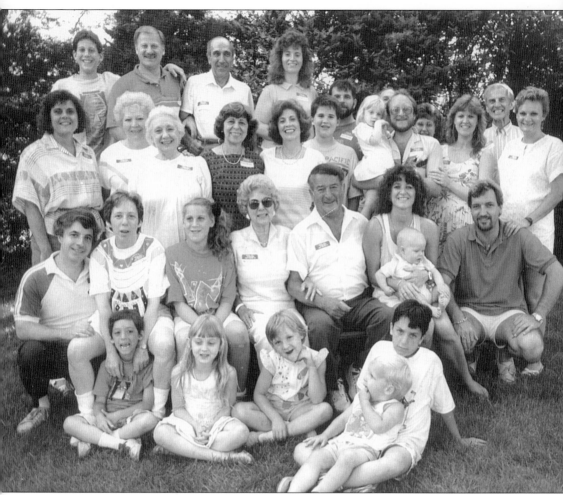

One of Clifton's many neighborhood get-togethers brought out the Meyers, the Kushas, the Sheins, the Toedters, the Grillis, the Hamiltons, the Pizzis, the Vizzis, and the Reads in the 1980s. The locale was Anderson Drive in the Montclair Heights section. The street is named after Clifton's Carl Anderson, who was killed overseas in World War II. To this day, Anderson's name lives on elsewhere, in the Kugler-Anderson Memorial Tour of Somerville, the so-called Kentucky Derby of cycling. In 1942, Anderson had won the tour. Today the Kugler-Anderson Memorial Tour of Somerville attracts cyclists from around the world to compete in the crown jewel of American cycling events. (Courtesy of Glory Read.)

Clifton's Mustang Marching Band leads the way along Allwood Road en route to Chelsea Park for the city's annual Memorial Day parade in the 1990s. It is an occasion for politicians to wave and perhaps shift a few votes; in the presidential election year of 1996, former vice president Bob Dole, the Republican nominee, marched in the parade. Yet he would lose the general election to the Democratic incumbent, Pres. Bill Clinton.

ACROSS AMERICA, PEOPLE ARE DISCOVERING SOMETHING WONDERFUL. *THEIR HERITAGE.*

Arcadia Publishing is the leading local history publisher in the United States. With more than 3,000 titles in print and hundreds of new titles released every year, Arcadia has extensive specialized experience chronicling the history of communities and celebrating America's hidden stories, bringing to life the people, places, and events from the past. To discover the history of other communities across the nation, please visit:

www.arcadiapublishing.com

Customized search tools allow you to find regional history books about the town where you grew up, the cities where your friends and family live, the town where your parents met, or even that retirement spot you've been dreaming about.